ONE RING CIRCUS

ONE RING

Extreme Wrestling in

photograph and text by
BRIAN HOWELL

with an introduction by
STEPHEN OSBORNE

PARALLAX

Vancouver

CIRCUS

the Minor Leagues

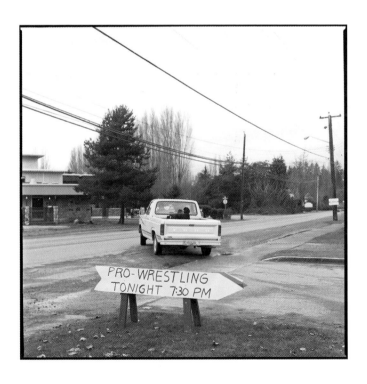

A PARALLAX book from
ARSENAL PULP PRESS
103-1014 Homer Street
Vancouver, B.C.
Canada v6b 2w9
arsenalpulp.com

The publisher gratefully acknowledges the support of the Canada Council for the Arts and the British Columbia Arts Council for its publishing program, and the Government of Canada through the Book Publishing Industry Development Program for its publishing activities.

Book and cover design: Solo
Editing: Stephen Osborne
Cover photographs: Brian Howell
Printed and bound in Canada

NATIONAL LIBRARY OF CANADA
CATALOGUING IN PUBLICATION DATA:
Howell, Brian, 1966-
 One ring circus

 (Parallax)
 ISBN 1-55152-132-6

1. Wrestling—Pictorial works. 2. Wrestlers—United States. 3. Wrestlers—Canada.
I. Title. II. Series: Parallax (Vancouver, B.C.)
GV1195.H68 2002 796.812'022'2 C2002-910929-9

One of the earliest images of wrestling known to archaeology is a bronze figurine said to be five thousand years old. It depicts two men grappling with one another, with their hands on each other's hips, and it was found in the ruins of a Sumerian temple near Baghdad, where, according to authors of *Wrestling to Rasslin: Ancient Sport to American Spectacle*, wrestling was associated with religious cults. Early examples of taunts and menaces employed by wrestlers to bait their adversaries can still be read on the wall of an Egyptian temple, where they were inscribed by wrestlers in training four thousand years ago. One of them reads: "Look, I'm going to make you fall and faint away right in front of Pharaoh," and another: "I will pin you! I will make you weep in your heart and cringe with fear!" Wrestling, in the words of Roland Barthes, has always belonged to the domain of "rhetorical amplification and magniloquence."

The earliest images of professional wrestling for people of my generation were in black and white, on television, right after the *Ed Sullivan Show* on Sundays at nine o'clock, when villains and heroes engaged in public combat on an epic scale otherwise to be found only in comic books. Every week, as my brother and I watched in astonishment, masked men with fierce names, courtly gentlemen, and crowds of midgets filled our living room with the sound of angry challenges and anguished cries and the smack and crack of body blows. The most spectacular of the villains was Gorgeous George, an effete creature with flowing peroxide-blonde hair who dubbed himself "the Human Orchid," and who was always preceded into the ring by a butler pumping a spray gun filled with disinfectant and Chanel No. 10 perfume.

The greatest opponent of Gorgeous George was Whipper Billy Watson, a champion of the Good, and a Canadian, who defeated Gorgeous George in a series of grudge matches that my brother and I followed avidly until its culmination in the notorious "hair vs hair" match. At the end of this contest, Gorgeous George underwent the final humiliation of having his golden hair shaved off in the ring. I remember my brother and me calling out to each other as Whipper Billy wielded the shears and Gorgeous George writhed beneath them: "They're really doing it! They're really doing it!" We had known as if by instinct that wrestling was not "really doing it," that wrestling was a performance, a kind of fiction – and now a moment of brilliant non-fiction threw that understanding into relief: wrestling becomes even more outrageous by inserting "reality" into its storyline.

Wrestling belongs to the world of the carnival and the spectacle. As Barthes puts it (in his 1957 essay, "The World of Wrestling"): "True wrestling is performed in second-rate halls, where the public spontaneously attunes itself to the spectacular nature of the contest." Wrestling is to be compared to Greek drama, and to bullfighting. "The function of the wrestler is not to win; it is to go through the motions expected of him." Appearances are everything in wrestling: the grand gesture of the hero, the overstated malevolence of the villain. Nothing is hidden; the audience is prepared to be overwhelmed by the obvious: obvious Suffering, obvious Defeat, obvious Justice: these are the tropes that wrestlers take with them into the ring. "What the public wants is the image of passion, not passion itself, " Barthes wrote. It was to this world of performance and violent athleticism, as it persists on the edge of mainstream media culture, that Brian Howell turned his camera in the late 1990s, when he covered a wrestling match in the Eagles Hall in New Westminster (a city of

100,000, part of the metropolitan exurbation of Vancouver) for a community newspaper. (Wrestling matches are almost never reported by big-city media.) He realized within moments that he had entered a world largely hidden from the public eye (that is, the big-city eye of the media); here was an "underworld," or "other world," with its own spectacular set of customs, conventions, rituals, and taboos, and its own practices and traditions. Here was a world that he wished to make pictures of.

Howell returned to the wrestling hall on his own, with his camera and flash, and began talking to the wrestlers and photographing them. He became knowledgeable in the field. Most of the wrestlers and the promotors whom he met were willing to cooperate and happy to allow him a glimpse of their lives and their art. For the next three years, as he could find the time, Howell attended wrestling matches in small towns throughout the Pacific Northwest. As he did so, his photography evolved into a style that we might call a photography of wrestling.

The camera traffics in appearances, and in appearances only, while pretending to reveal what is hidden by those appearances. Hence the camera has difficulty with activities that (appear to) hide nothing; such is wrestling, which seems to hide not even its own artifice. In a sense there is nothing in wrestling for the camera to reveal: everything is there on the surface. We have a photography of boxing and we have a photography of jazz music (in a way those activities are given their ambience by an intimate black-and-white photography), but there is no photography of wrestling. In a very real sense there can be no "candid" photography in a wrestling hall, where everything is drenched in the same light; even in the murkiest of venues, nothing is "hidden"; neither is there any privacy to reveal: all moments in wrestling are public moments. All of wrestling consists of formal gestures more or

less expertly improvised by both performers and fans. Howell realized quickly that his small range-finder camera, which he handles brilliantly in other venues, and whose speed and flexibility make it the ideal instrument for revealing the "decisive moment," failed to reveal much of what he was experiencing in the world of wrestling, a world in which no moment is decisive, in which all moments are stretched out. The end of a match, for example, is always drawn out, never sudden. One can say that wrestling is itself a photographic way of presenting reality: the moment has already been "captured" by the performers. Howell turned to a larger medium-format camera, which produces a much more premeditated photograph. He began composing images on the ground glass as the action around him unfolded, and he began making the simple and powerful portraits of wrestlers that punctuate the images in this book. In the marriage of the formal portrait and the formal gesture, Howell found a way to respond to wrestling that remains true to its subject: even his action shots are formal compositions. On the cover of this book, a heavyset man holding a soft drink pauses before the camera after a match: he seems merely to have to present himself to the lens for everything to be revealed. In this image nothing has been "captured," or snatched from the passing flux: the image and the moment have duration, as do all moments in wrestling and in all spectacles of excess.

This is a book with many virtues, a work that can be savored for the brilliance of its photography and for the stories it contains of a world unnoticed by many of us: it shows us something that we didn't know before. At the same it returns the world to its subjects: the wrestlers themselves and their fans, who are presented here unsentimentally, with dignity and honor. And what is wrestling, we continue to ask? In the Bible, Jacob meets an angel and

wrestles with him; in the book of Enoch in the Dead Sea Scrolls, angels of Good and Evil struggle for our souls by wrestling with each other; they do not box or duel, exchange parries or pistol shots. Wrestling is duration: wrestling endures.

Wrestling in North America is dominated by World Wrestling Entertainment(wwe), a wrestling promotion formerly known as the wwf, and whose extravagent televised matches are watched by millions around the world. The "minor leagues" of the wrestling world are the purview of independent operations such as Extreme Canadian Championship Wrestling (eccw), headquartered in Surrey, bc, whose territory is the Pacific Northwest. eccw shows travel as far north as Prince Rupert near the Alaskan border, across the Gulf of Georgia to Vancouver Island, and over the line to Washington state. The wrestlers perform in towns and smaller cities, in community centres, high school gymnasiums, Legion Halls, and other low-overhead venues, in front of die-hard fans who treat them like stars. Again and again, they put on their masks, costumes, and makeup, and get into the ring, where promised grudge matches are fulfilled, old challenges met, and new tag teams created to fight "for the first time ever." At the end of the evening, the lights go up, the ring is dismantled, and chairs are stacked; autographs are signed and bloodied faces washed clean. But the age-old story of good versus evil will play out again; familiar characters will soon be back. And so will the fans.

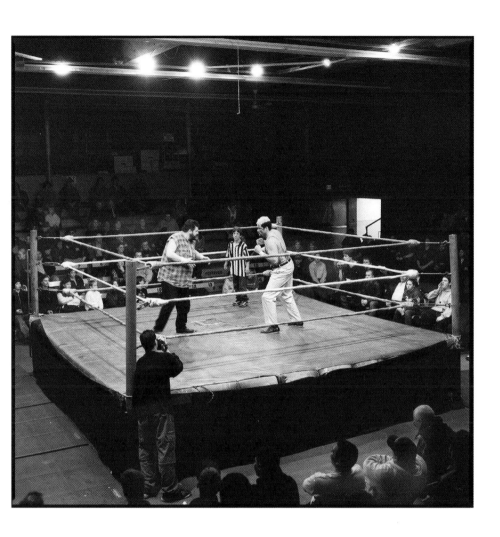

Mark Vellios is thirty-four years old and a father of three. During the week he runs a moving company in Surrey, BC. On Friday night he pulls on his pink tights, styles his peroxide-blonde hair, and draws a lurid star over his left eyebrow with pink lipstick, thereby transforming himself into Gorgeous Michelle Starr, wrestler and part-owner of Extreme Canadian Championship Wrestling (ECCW). When he enters the auditorium, the crowd begins to chant: "Ho-mo! Ho-mo! Ho-mo!" His wife Sue watches the door and takes tickets. Gorgeous Michelle Starr makes his way into the ring and picks up the microphone. "I've told you guys I'm not a homosexual," he says. "And I'm not a hetero-sexual, either. I am what you call a trisexual, and after I'm done in the ring, I'm going to try each and every one of you right there in that corner!"

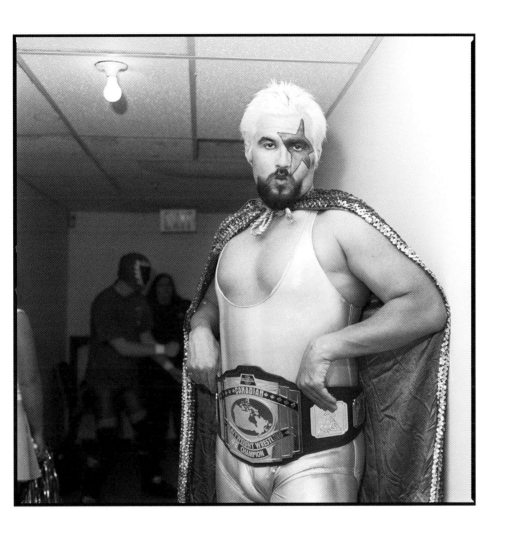

PARTNER

John Parlett is Gorgeous Michelle Star's business partner. He had been a fan of All-Star Wrestling for years before finding himself in the wrestling business. He often appears a the ring announcer dressed as a hippie or a pimp named T.J. Sleaze. Parlett was instrumental in shaping the direction of the early ECCW shows at the Eagles Hall in New Westminster. The adult-oriented hardcore productions soon developed a cult following with plenty of violence, blood, superb athleticism, rampant homophobia, racial slurs, and lots of laughs. Definitely not for the politically correct. But the Eagles Hall venue has since been lost (it's now the Raymond Burr Theatre) and ECCW is still in search of a venue with the same magic. Three years later, die-hard fans continue to talk about the legendary Eagles Hall shows.

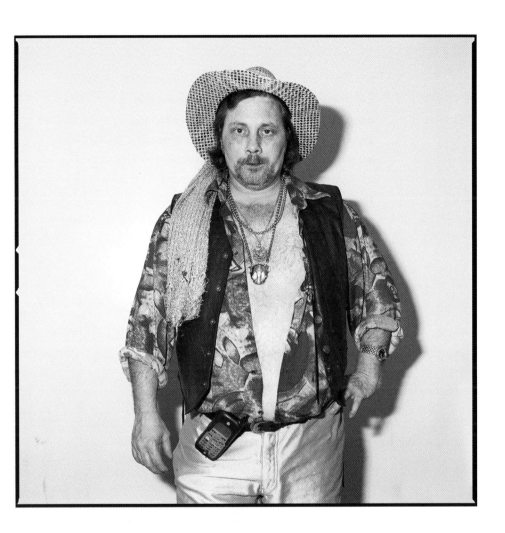

ECCW is a stopping-off point for wrestlers working the West Coast. Veterans like Giggolo Steve Rizzono from San Francisco heighten the stature of the shows when they are booked in for a few weeks. Rizzono has the qualities of the old school wrestler: big, tough, charismatic, great with a microphone, a good worker. In the late '90s, Dave Republic (background) came in as an investor and ring personality, and took on the role of "comissioner." He took his share of abuse in the ring, both verbal and physical, while behind the scenes he was dealing with the pressure of making ECCW a financial success.

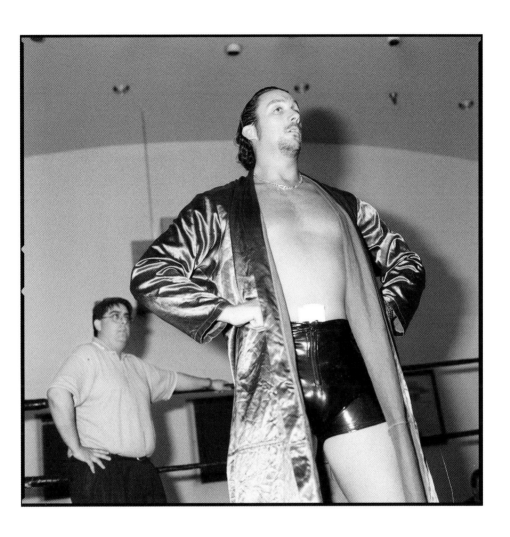

Borne Again

Portland-based Matt Bourne traveled up and down the west coast with his ace student Tony Kazina, and the pair is credited with carrying the promotion on their shoulders in the early days. Matt brought a great deal of experience and professionalism to ECCW. His father, Tough Tony Bourne, was a wrestler of renown on the west coast, and Matt was raised in the business. Matt did his time in the WWF, appearing in the first Wrestlemania, the Super Bowl of professional wrestling. After a falling out, he left the WWF, only to return in the early '90s as Doink the Clown, but he was fired at the height of the role's notoriety and was no longer allowed to play the role. But even as Matt Bourne, he could still sell tickets.

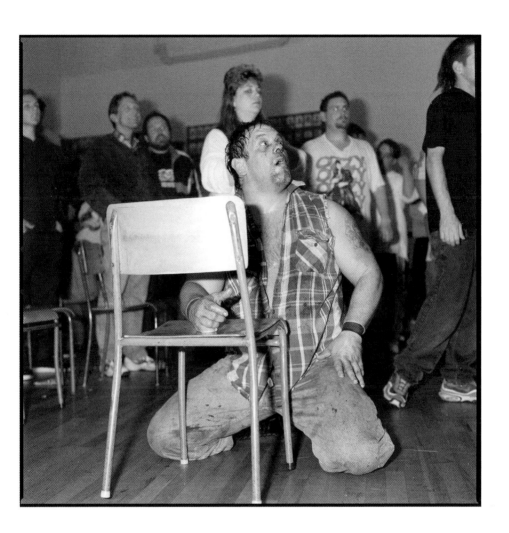

Referee

Verne Siebert is well known to local fans from his days as a wrestler with All-Star Wrestling in the '80s. He still takes the odd bump in the ring and helps train new talent at the House of Pain wrestling school. A wrestling referee is almost like a host to the match: he inspects the wrestlers for concealed weapons and goes over the "rules," and is as much a part of the match as the wrestlers themselves. At the end of the match, when a wretsler is pinned, he dives down on the mat and slaps out the three-count. Then he grasps the victor's hand and raises his arm triumphantly.

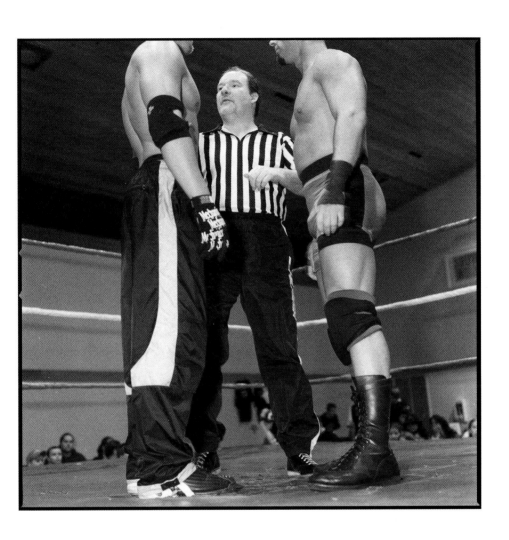

Aspiring wrestlers undertake their training at the House of Pain Wrestling School, located in a warehouse at the back of an industrial park in Langley, BC. Every Saturday night John Parlett puts out a sign out on the highway reading: House of Pain Show Tonight, 8:00 pm. These intimate and informal shows provide an opportunity for students to work with veterans, while learning to perform in front of a small and loyal group of fans. At intermission wrestlers and fans mingle in the parking lot. Amy was trying out a new gimmick she called Living Dead Girl. She wore the outfit only that night because the boots compromised her ability to move around in the ring and as a Christian, she was concerned about portraying someone so evil. The following week she appeared at the House of Pain as a cowgirl.

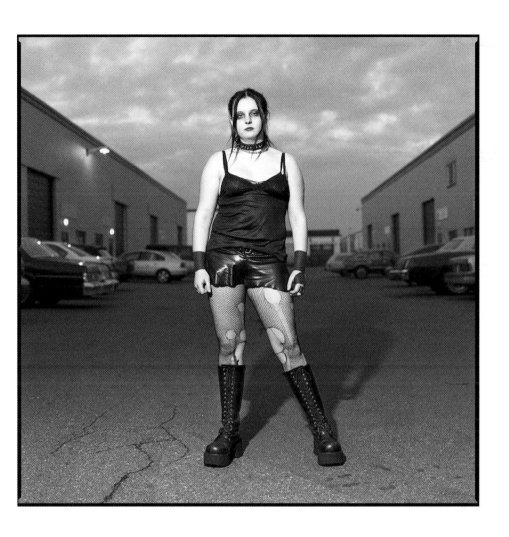

The fans seem divided on what to make of the tough guy with a flair for homoerotica. Some of them are calling out, "Johnny sucks!" and others are yelling "Johnny's my dad!" as Johnny Canuck circles the ring in his logger's mackinaw, stuffing food offered up by his fans into his mouth. Sometimes he eats and drinks so much – chips, hot dogs, pop – he can hardly wrestle. Johnny has a family and works as a longshoreman by day. He says, "People would be locked up for doing what I do. I get to do it for fun."

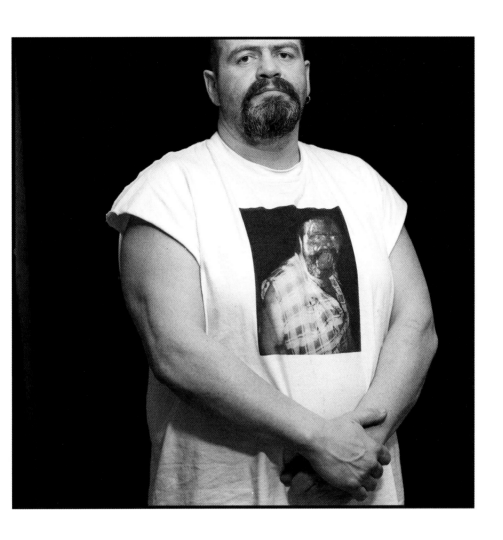

Theatre

There were once two movie theatres in downtown New Westminster – grand old halls with balconies, backlit marquees, and all those light bulbs. One of them now houses a lapdance club, and the other became the Eagles Hall and lost its architectural beauty in a bad renovation. The movie screen has been replaced by a stuffed eagle in a glass case mounted high on the wall. Once a month ECCW would come in with their ring and set up beneath the chandeliers. It was a perfect venue for wrestling.

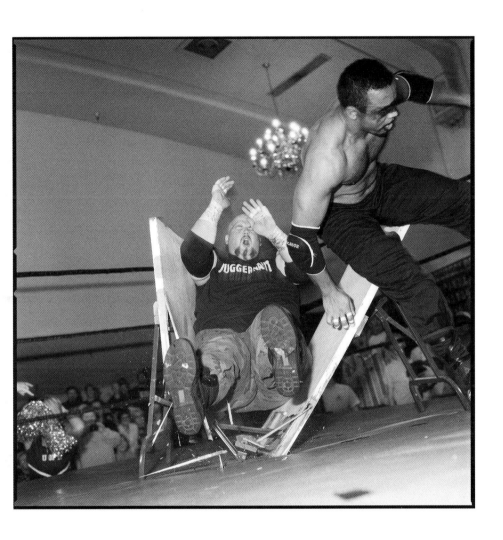

Metamorphosis

Backyard Billy was a wrestler who lost a "loser leaves the ECCW" match and walked out of the Bridgeview Hall to a standing ovation. Three months later he was back wearing a mask and a tight black and white suit. His gimmick had evolved into a masked superhero named White Tiger, enabling him to sidestep his "banishment" from the circuit. Wrestlers often express a part of themselves through the roles they play.

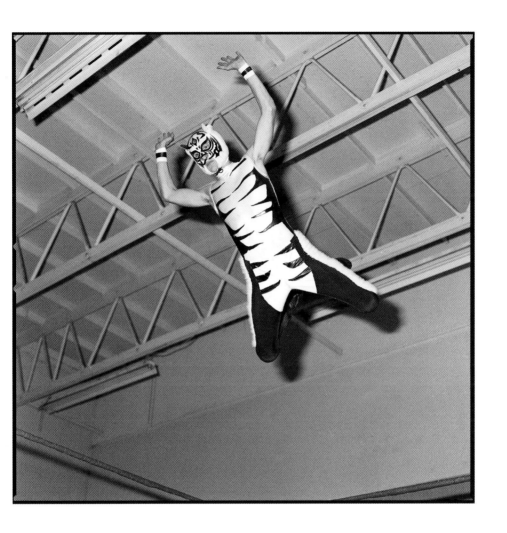

Beautiful Bruce

Many wrestlers dream of the opportunity of making it to the WWE. Beautiful Bruce got his shot in 1998 when he got a one-time call for a midget act at the Tacoma Dome in front of 14,000 people. He appeared just the one time and hasn't been called back since. "It was a big thrill being in the same dressing room as the guys I had watched on TV," he said. Michelle Starr bought him the suit in the boys department at JC Penney on the day of the Tacoma match (and Moondog Manson insisted on taking him for a haircut). Beautiful Bruce wore the suit back in Canada all through 1999, as Disco Fury's manager.

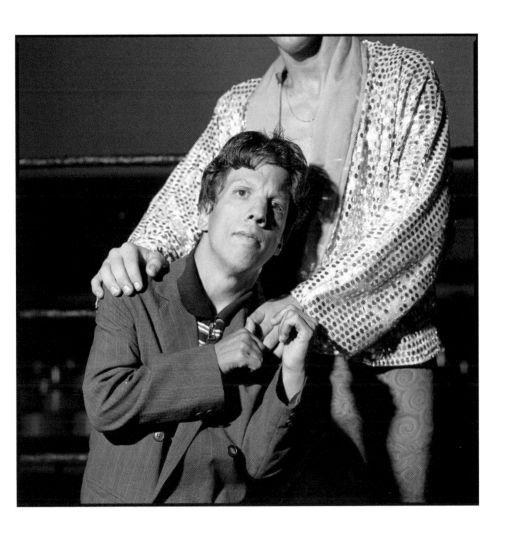

"If you think you just have to look good to be a wrestler, then don't do it." Nicole Jakal was a single mother when she enrolled at the House of Pain. She had a full time job and was studying at the university to be a shop teacher. She came onto the scene as "Buffy" when there were few women wrestlers in the Pacific Northwest. Although she wears a cheerleader outfit, standing on the sidelines and cheering for the boys was never Buffy's role. She quickly became popular with fans, as she has more athletic ability than many of her male opponents.

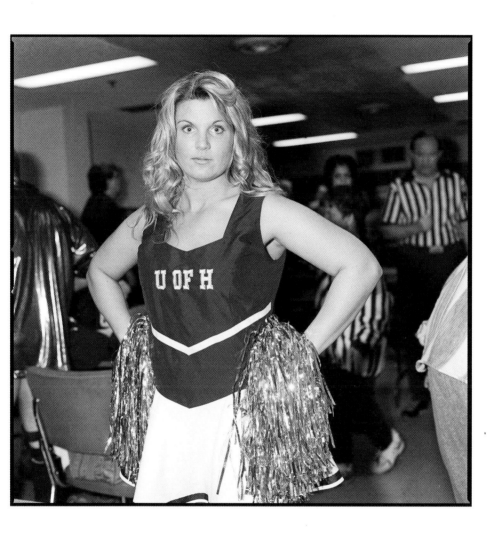

FANS

Cathy and Linda have been wrestling fans since the '70s and they were regulars at the New Westminster shows. Their favorite spot at ringside was always held for them, even when they were late, as they were for a packed night at the Eagles Hall when they they rushed in halfway through the show and their chairs were waiting for them as they pulled off their raingear. They had a big green garbage bag with them filled with signs they'd prepared earlier that day and some they had collected from previous shows. One of them read: "Hey Gigolo you sexy thing. Can I have your hotel key?" The wrestlers know Cathy and Linda by name and always stop by on their way to the ring for a high-five or a lap dance.

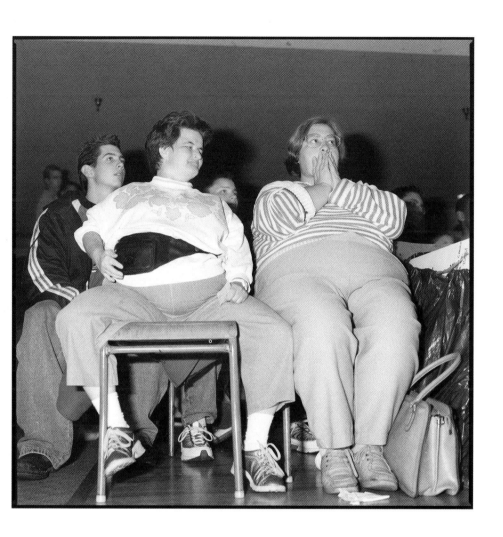

Volunteer

Donald reached up and grabbed the top rope as I prepared to take his picture, stepping instinctively into his self-appointed role as guardian of the ring. Donald patrols the area around the ring picking up capes, boas and hats, weapons, bloodied chairs, and debris from broken tables. He returns the wrestlers' personal belongings to the dressing room and tucks other debris under the ring, away from the action. At the indie level where funds are tight, there is never a budget for security staff. Volunteers are welcome and highly regarded.

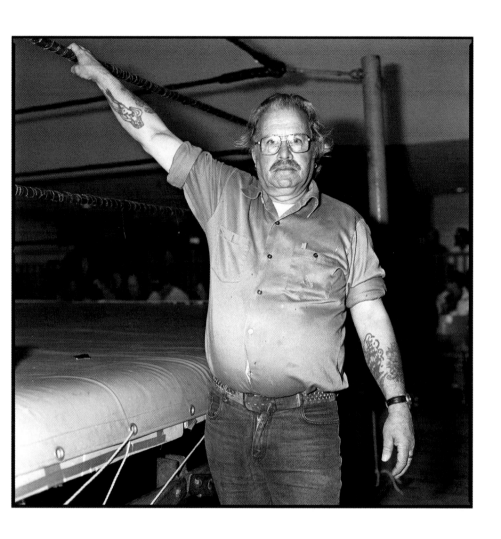

Show Time

At Mount Currie Reserve about a hundred miles north of Vancouver, a soccer tournament has drawn out half the town and a six-thousand-dollar bingo game has drawn the other half. A girl with a battered hula hoop hangs around the entrance to the wrestling venue. It is lonely and hot and dusty and after a while she takes a seat in the shade. The boy inside is waiting for someone to come and buy a ticket. Small towns can be a tough sell. Sometimes in the indie wrestling business the wrestlers outnumber the fans.

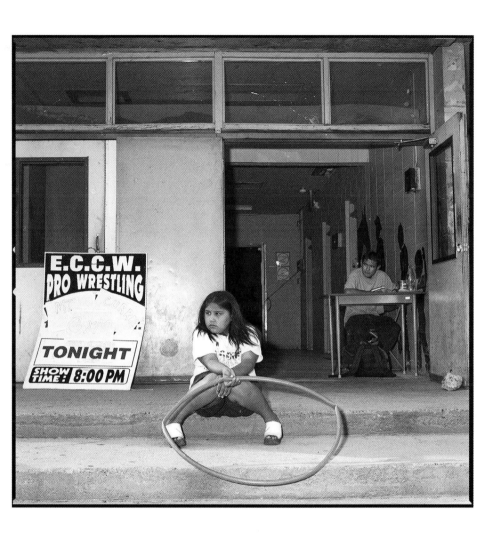

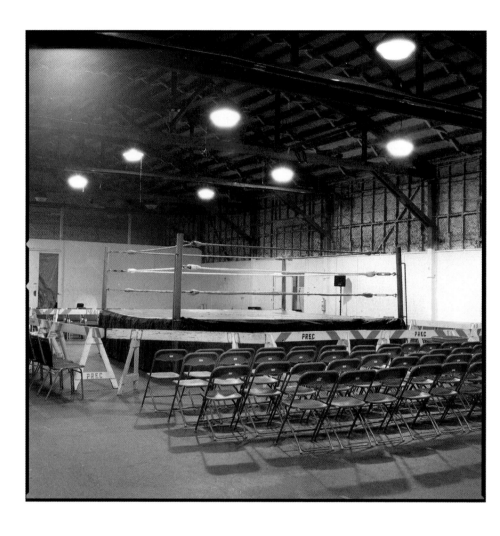

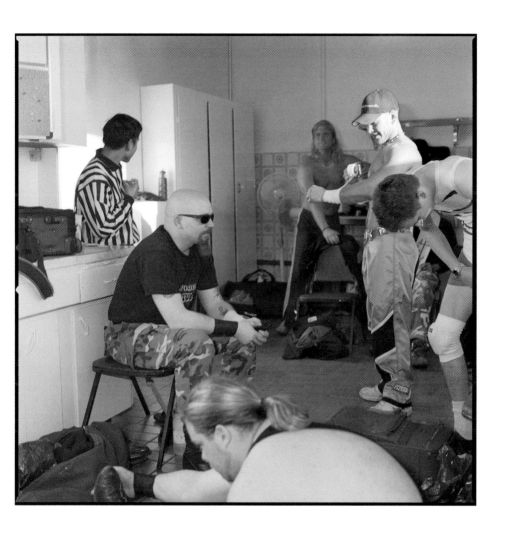

Ladies Choice

Good-looking male wrestlers are often not appreciated by the adolescent male crowd. Ladies Choice, a true student of "old school" wrestling psychology, knows how to push their buttons. He taunts them by warning them that he'll be going home with their girlfriends.

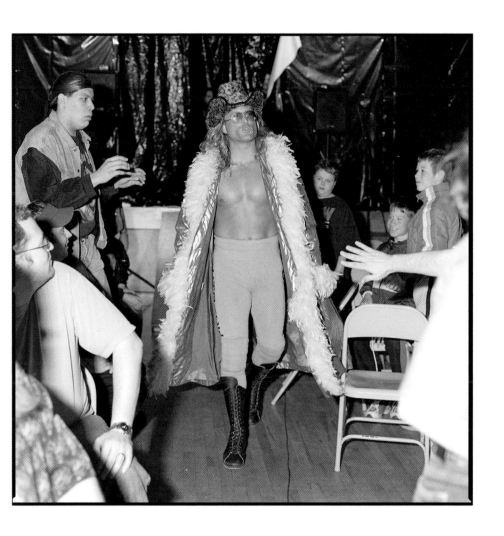

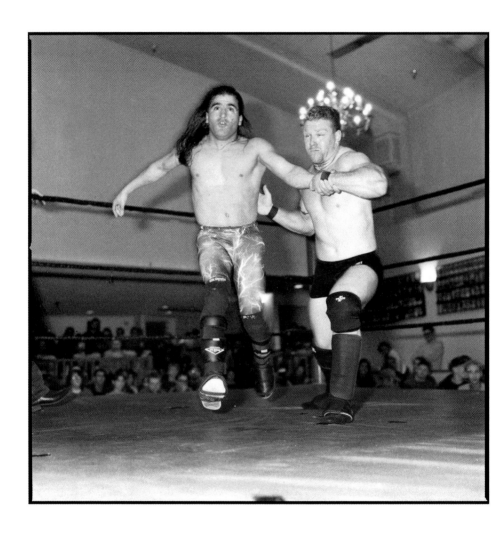

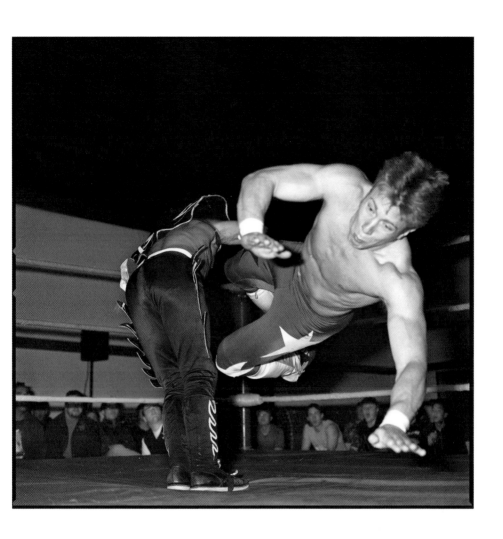

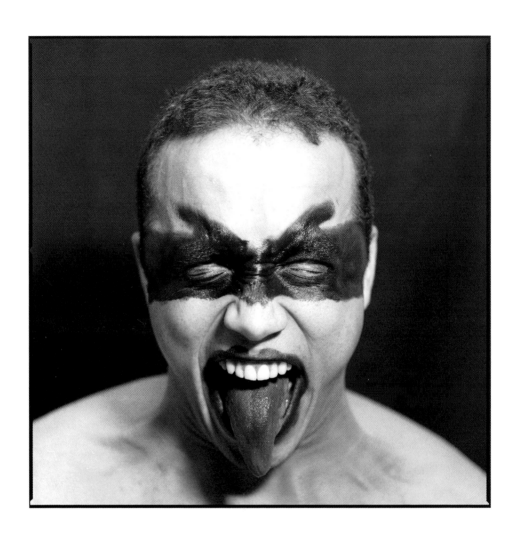

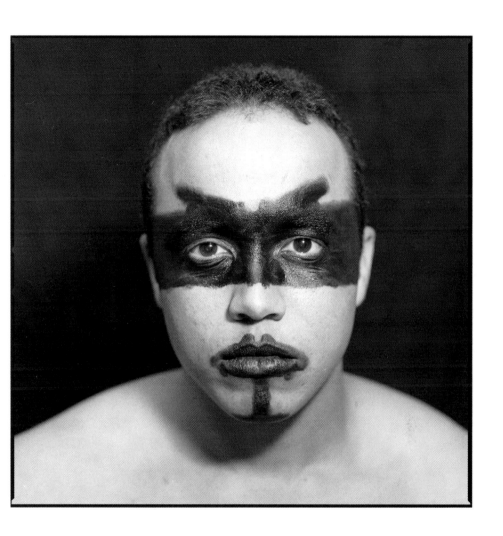

Private Todd Kelly is speaking: "The dream – that's pretty much what drives someone. If you're willing to come here and wrestle in front of fifty people, you've gone through all your classes, you've started to pay your dues – you're finally getting a chance. If you can get draw someone's attention – that's how it all happens. That's how you get noticed. I look at TV now and I think to myself all those guys who paid all that money to go to *Tough Enough* [a televised series of elimination matches for would-be wrestling stars, sponsored by WWE and MTV]. I looked into that – you had to fly yourself to New york three times before they put you up in a place, so rich people got a chance to do that. I'm a guy with a family and I kill myself to get looked at. It's all done for that one chance, that one little chance. *Tough Enough* guys, I almost see all of them get hired on as contracts now. Why? Because they've already been looked at. They haven't gone on to the independents, a lot of them, and paid their dues, busted their ass – wake up in the morning after forty front buckles and seeing a black mark on their chest from bottom rib to chin. That's where the WWE is getting cheated, they're getting guys that just paid money to get there. My day job is loans officer at a pawn shop – steady day job and a young family and I train a lot. I go to the gym from seven to eight and do mainly weights because I need to put on weight. The best thing about wrestling is getting people off their seats. It's my job to have people hate me. If they're throwing bottles, airplanes, whatever – right on. If you're gonna throw coins, make 'em loonies and toonies. Everybody wants their name chanted, whether it's good or bad it doesn't really matter as long as you're getting chanted. Silence sucks – in wrestling silence sucks. If someone yells at me, I'll pick on him, I'll say, "Let's see you get in here, fat boy!"

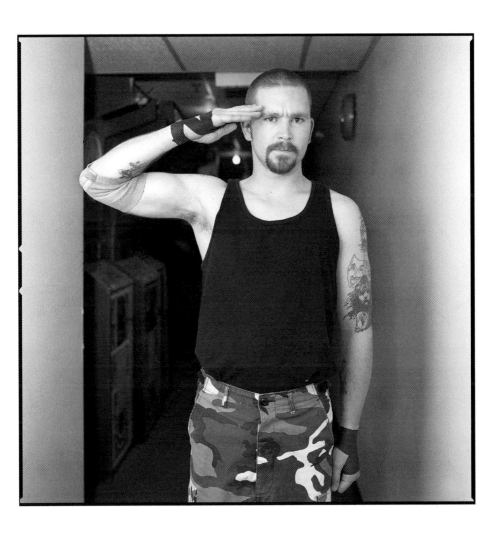

Scotty Mac says: "Every wrestler's dream is to make it to the WWE, that's the big goal. Whether anyone's gonna make it there is different story. If I continue doing this on the side until I'm forty, I'd be thrilled because I'd still be wrestling. If I didn't have the ability to advance I'd be happy here, but I do have the ability to go further and I will."

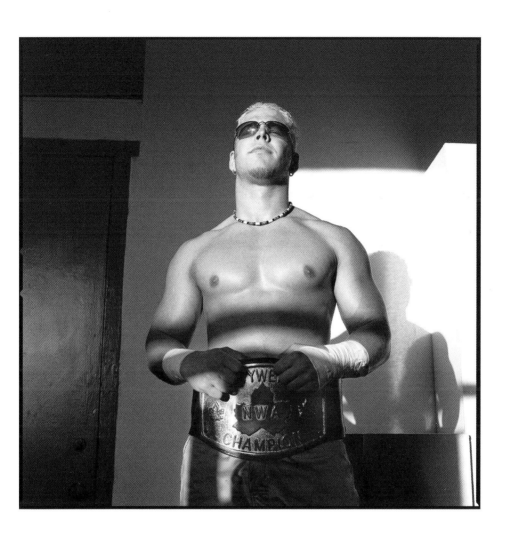

Bam Bam Bambi

I am loading my camera and talking to fans before the show at the Bridgeview Hall when I notice Bambi on the other side of the room. She looks like Marilyn Monroe with her stars and stripes and blonde hair. She is posing for photos for her website. She made the suit herself and brought fabric from home for a back-drop which she taped to the wall. Bam Bam Bambi is a skilled seamstress and she makes costumes for some of "the boys" as well as for herself.

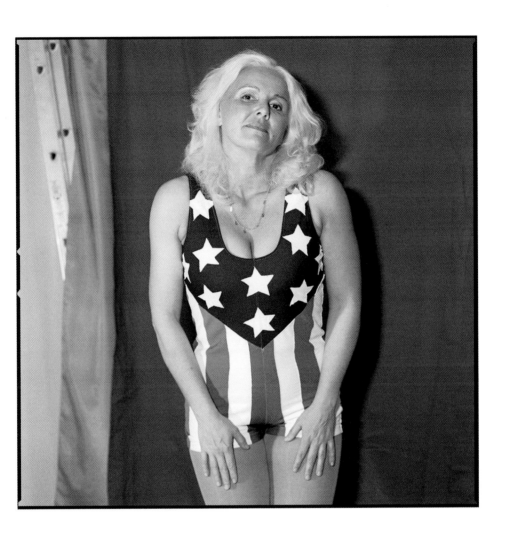

WAGER

When Ladies Choice lost a challenge match to Moondog Manson, he also lost Veronica Lake, his beloved valet. Veronica is allowed to cool him off with her fan one last time before being led off to the dressing room by Manson.

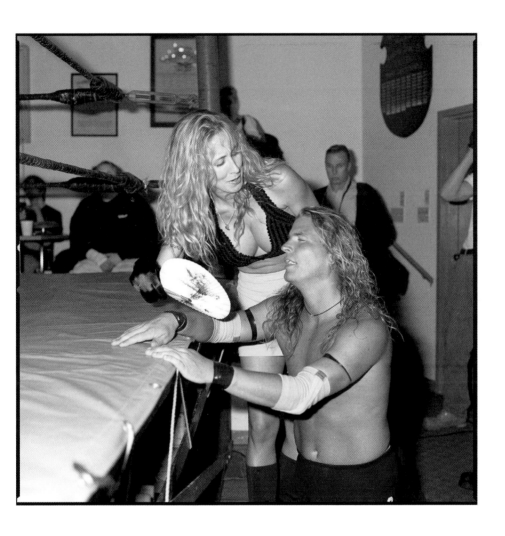

Although it can be an expensive risk, ECCW continues to bring in international talent to work a couple of shows. The Honky Tonk Man used to be a big star in the WWF, where he was known as the greatest Intercontinental Champion of all time. He lives in Arizona and works the independents around North America.

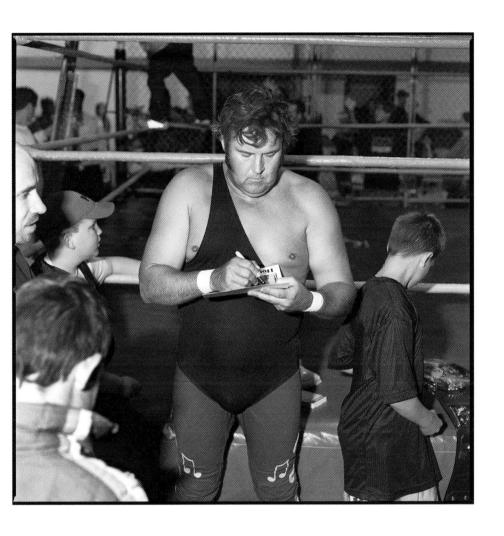

FALLEN ANGEL

Christopher Daniels from California is Fallen Angel: a class act and a big draw. Fans show up for his matches with signs and T-shirts bearing his name. Fallen Angel is recognized as one of the best unsigned indie wrestlers in the United States.

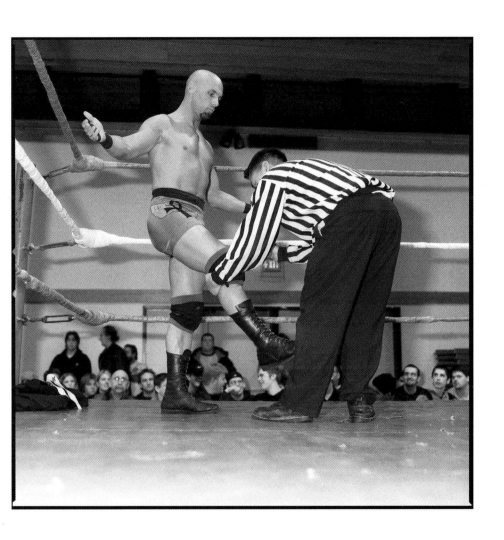

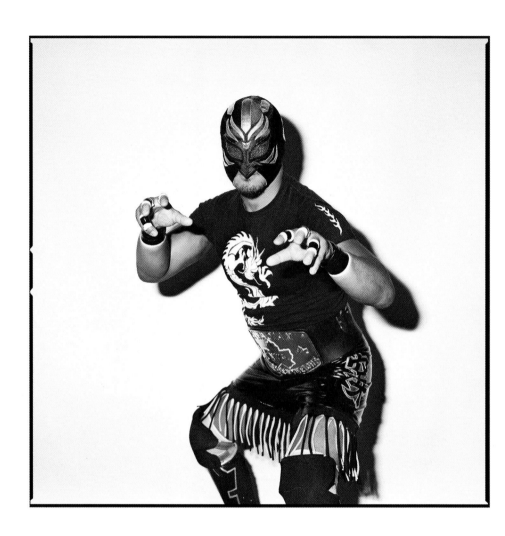

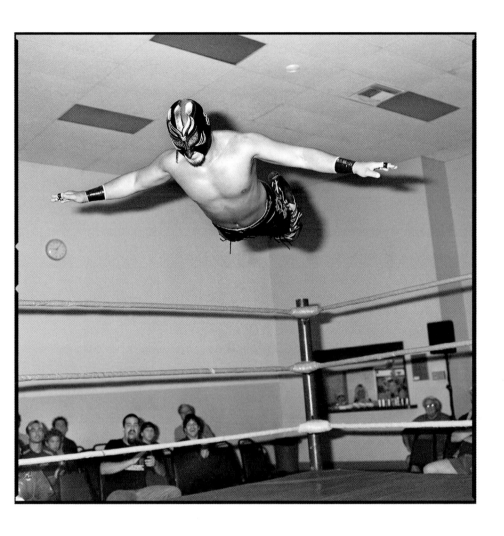

Len St Claire traveled to Japan to wrestle in the Japanese circuit (FMW), where he transformed himself into a menacing Hannibal Lecter knock-off, Dr Luther. Baseball stadiums soon filled to capacity to witness his bloodbaths against Japanese opponents. But he discovered the character was too extreme for mainstream North American promotions. A long-time friend of Starr's, Dr Luther commuted between the west coast and his bookings in Japan and soon developed a cult-like following in ECCW despite being solidly, purely evil. The fans view him as a genuine star.

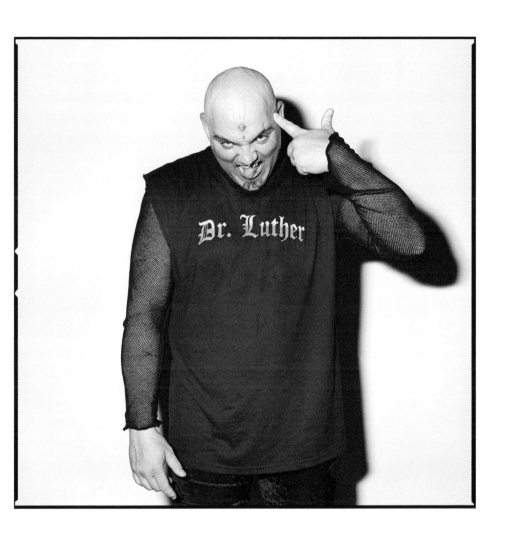

CREMATOR

Cremator's gimmick is an homage to Michael Myers, the psycho killer from the *Halloween* movies. "I could relate to the rage inside him," says Cremator. "The ring allows me to get away from the frustrations of life. I wrestle because I like to perform, and it makes me feel like I belong somewhere." Cremator is six-foot-four; he moves deliberately and rarely speaks in the ring. When he gets dumped onto the mat he pops straight up like a cadaver springing back to life. His grandmother is uneasy about him being a wrestler but she doesn't mind making his trousers for him.

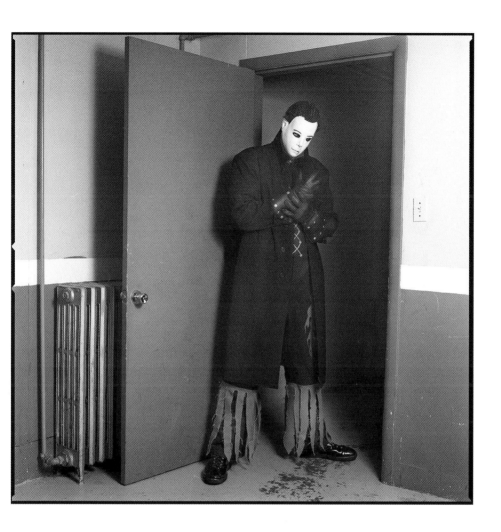

Freddy

Freddy Krueger appears one night at the Eagles Hall in New Westminster. The gimmick is a good one since the fans already know the character. In this instance the Japanese wrestler Hiroki brought the mask with him from Japan, where monster characters are always popular, and one of the ECCW wrestlers brought it to life. They work especially well when there is a small group of wrestlers and one of them has to play two roles during the evening.

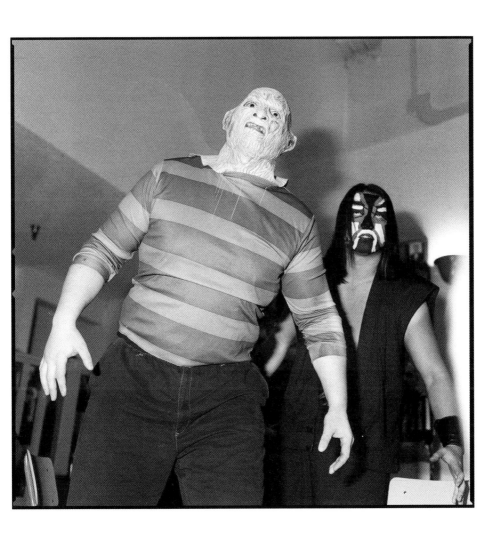

WRATHCHILD

Wrathchild got into wrestling after some trouble with drugs. As part of his recovery, he was motivated to do something with his life. He works a full-time job and has no aspirations to make it in the WWE, which is unusual among wrestlers. He has to take time off from his job to go on tour; he often punishes his body, particularly his forehead, which bears many self-inflicted scars. As he puts his makeup on before a show he is light-hearted and enthusiastic about giving the fans a great show.

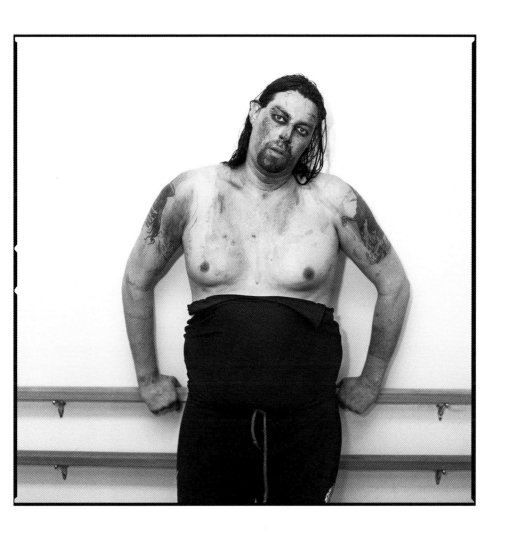

Signage

The audience at most ECCW events is diverse: old and young, men and women, familes, and teenaged girls and boys. The atmosphere at the show can be so intense that fans as well as wrestlers can push things beyond what might be acceptable at a "normal" public gathering.

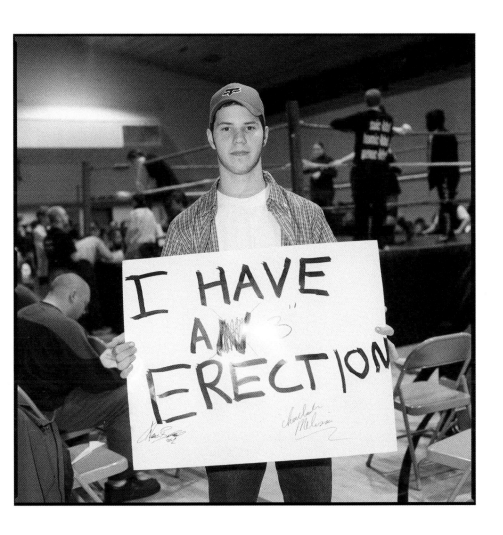

Ring

The wrestlers assemble at the hall in the afternoon, usually around three o'clock, and begin unloading the ring and other equipment off the trailer. Getting the ring up is a heavy, dirty job, much like a carny crew assembling a ride. The ring takes about an hour to assemble and is 16×16 feet square and made up of twenty-four 2×8×16 foot planks laid edge to edge. A thin layer of foam is laid over the planks and tied down with a tarpaulin. Multi-coloured ropes hold the corners of the ring together and can be adjusted by loosening and tightening a series of turn-buckles.

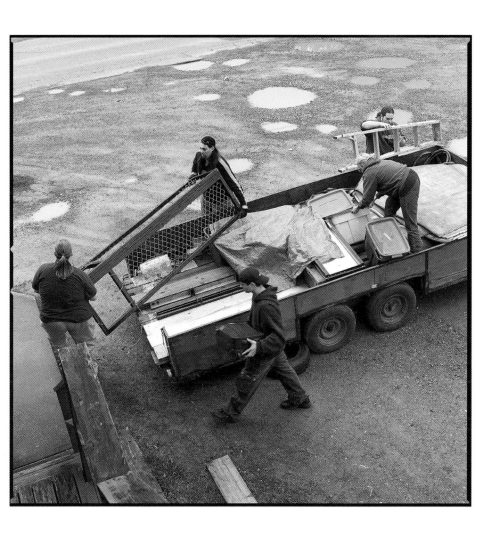

Thursday nights at the Legion are Meat Draw Nights, just as they have been for years. On Friday nights you see people in suits, dresses, hairdos in the lounge bar at Branch 133. There are bar-flys, blue-collar heroes, and a few aging vets: beer, cigarettes, and that familiar musty smell. Faded photographs and dusty trophy cases. But the day of the Legion is dwindling, and the auditorium which once would have been filling up with dancing couples has been rented out for wrestling matches. Tonight the auditorium will be nearly empty. ECCW is making its debut in a new town, and it takes time to build up a local fan base.

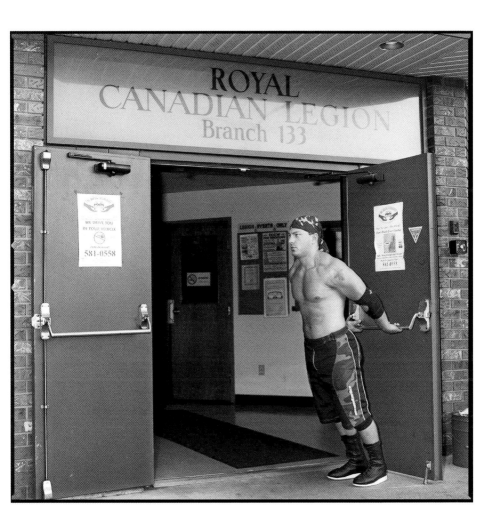

I drove into town in the morning and went looking for some bacon and eggs. I found this place near the water and smiled when I saw the wrestling poster in the window. Were the customers thinking about wrestling as they looked over the lunch specials? What did they think about Moondog Manson and Wrathchild coming to their town? The waitress hadn't noticed the poster and didn't know about the show. Apart from their website, ECCW relies solely on postering to promote their shows.

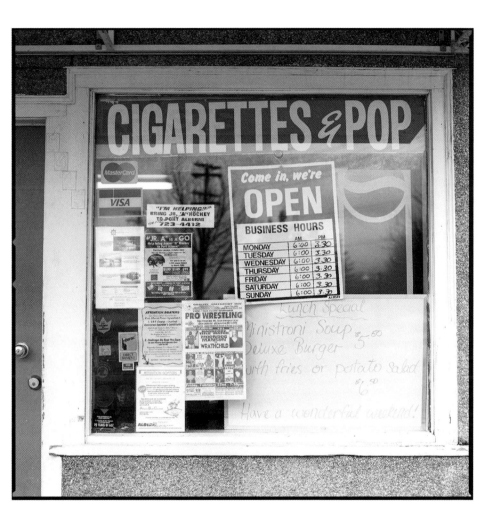

BEAUTIFUL BRUCE

Bruce had the flu on the Vancouver Island tour but he got the job done. He likes being in front of the fans but admits that he still gets nervous at times, particularly with big stars like The Honky Tonk Man or Jim Neidhardt. Bruce was in a record store in Vancouver when a couple of kids called out to him: "Hey, there's the referee!" "It's kinda nice when people recognize you," he says.

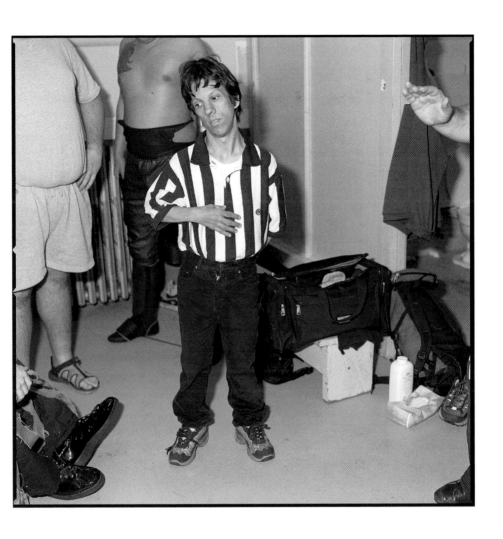

FAN

Klondike Bill always showed up dressed as a prospector. He was a Juggernaut fan and the moment Juggernaut's distorted heavy metal entrance music started, he would start rocking back and forth and whispering, "Get him, Jug! Get him, Jug!" Klondike Bill could also be seen standing on chairs and moving about the hall throughout the match, angling for better views of Juggernaut, who rarely fought inside the ring.

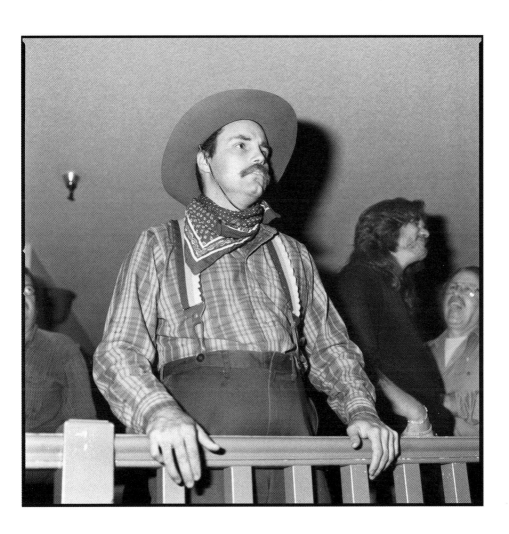

Disciple

When the villainous Dr Luther made a triumphant return to
ECCW after a prolonged absence, fan Bruce Bignell, his self-ap-
pointed ringside disciple, was there to celebrate. Bruce usually
shows up wearing a black shirt with blackened eyes and carrying
a red duffle bag. As Dr Luther approached the ring in his menac-
ing way, Bruce was on his feet gesturing, grimacing, and grin-
ning wildly from sideburn to sideburn.

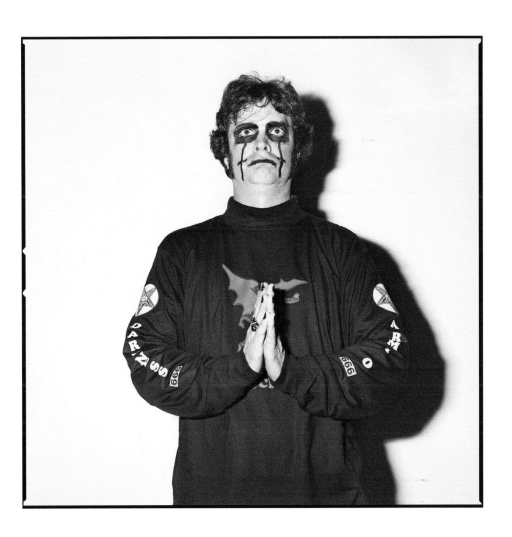

GIRLS

The girls from Ucluelet line up for five-dollar Polaroids of themselves standing next to Scotty Mac, who puts his arm around their shoulders. Scotty Mac sells more merchandise than the other wrestlers, most of it to teenaged girls like these ones who ask him politely to autograph their clothing and their arms as well. In small towns, this is often the closest people ever come to meeting celebrities.

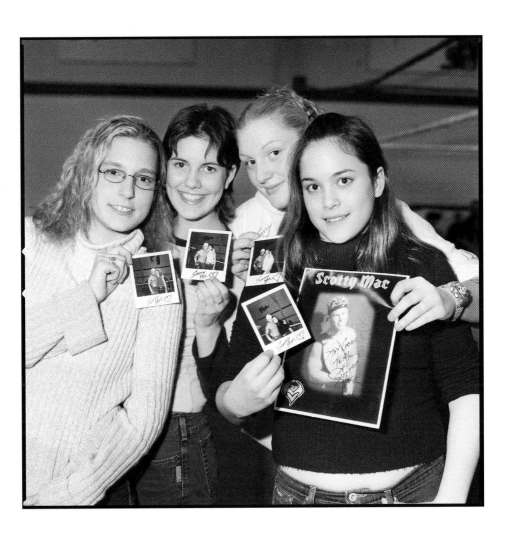

VIRGINIA AND BILL

Seats at the show are ten bucks, fourteen if you want the front row, although you can usually move up to the front once the show starts. Bill and Virginia are long-time loyal fans and they always pay the extra four bucks for the front, which is also a good place for Bill to sell the smoked salmon he keeps in plastic bags under his chair.

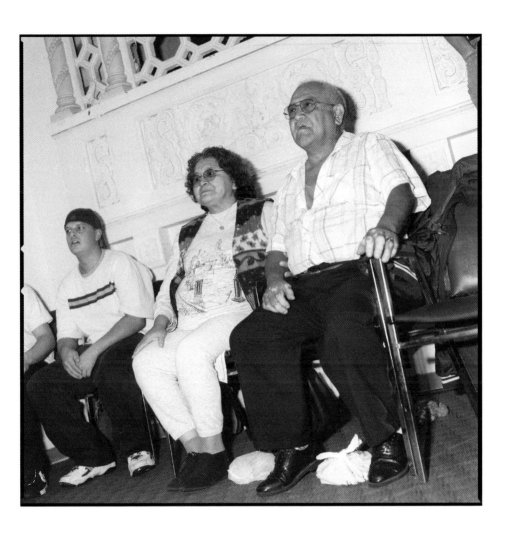

KANDISS

Kandiss attends nearly every show and helps out by handing out pamphlets, selling raffle tickets, and anything else that needs doing. She says the wrestlers are cool and she likes hanging out with them. It's like a big family, a home away from home. At a recent House of Pain show she was invited into the ring to celebrate her birthday. She likes the atmosphere around the shows, which get her away from the stress of her life. She doesn't like all the hype around the WWE and loves the fact that she can be up front and personal with the local guys. She is thinking of enrolling in the House of Pain Wrestling School and says she would love to be a valet for Scotty Mac.

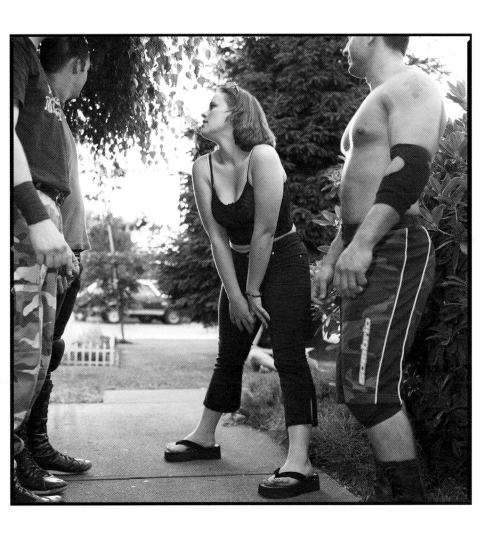

"Sometimes it's quite a rush, bleeding like that," says Moondog Manson. "Other times it's a bit of a pain in the ass. When you cut into your head with a razor blade, it can feel like you dug a dagger into your forehead. It can be painful and other times you don't even know you did it, it just feels like sweat on your face. I get off on it pretty much – that's why I do it every show. One time after getting colour four nights in a row – we were in Salmon Arm for the last night and I had lost so much blood, I was trailing it all over the gym, people were actually sickened that I was losing so much blood. We had to drive back home through the night and go through the mountain pass, over the Coquihalla Highway. I almost passed out from the altitude and the lack of blood."

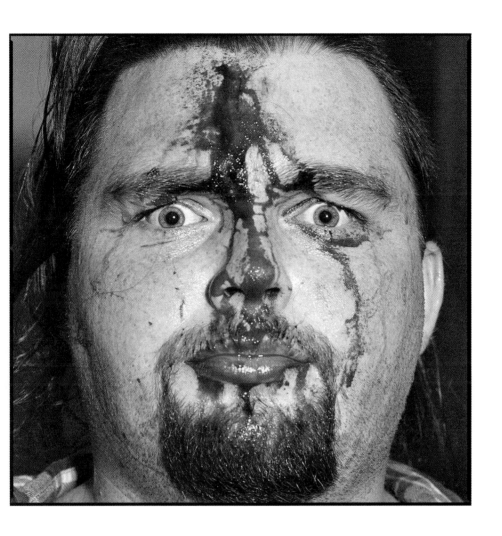

Disco Fury

Started his career as Fury, progressed to Fantastic Fury, and on a slow night in Houston, BC entered the hall to "Stayin' Alive," did some dance moves, and became Disco Fury. Disco Fury has always wanted to be a professional wrestler. He's twenty-six years old and he's been with ECCW for four years, wrestling around the Pacific Northwest, and traveling to the UK where he appeared in front of considerably larger crowds. He predicts that soon he'll be performing with one of the top wrestling organizations in the US. The WWE won't look at you if you don't weigh at least 215 pounds. When I took this picture Disco Fury weighed 163 pounds. He now weighs 195. It took him less than a year to put on the weight.

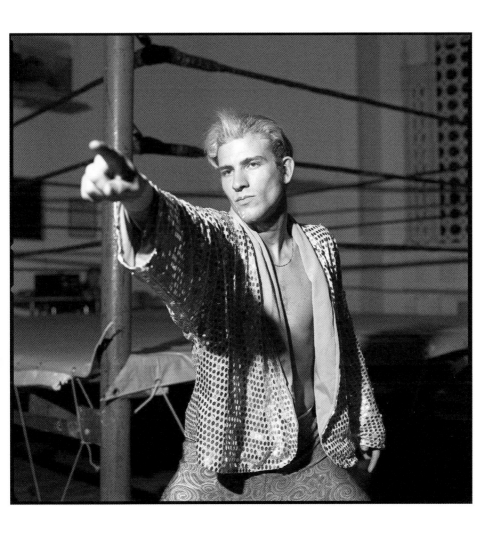

Cheechuk came into the dressing room after his match with Wrathchild and Killswitch had erupted into a brawl when Michelle Starr jumped into the ring. Cheechuk was exhausted, breathing heavily, and bleeding from the forehead. He stopped for me to take this picture and then took a pull from his can of root beer, walked outside into the pouring rain, and vomited over a railing.

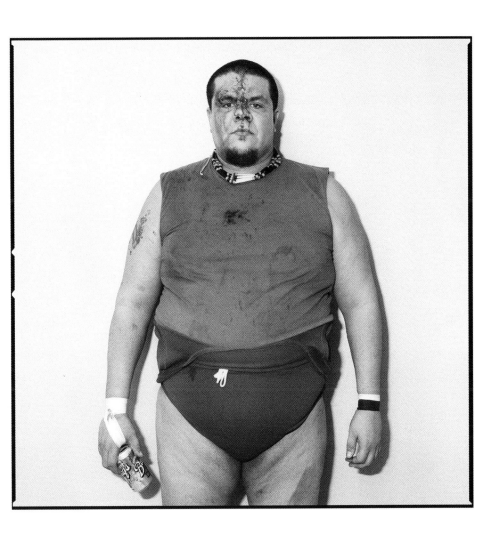

Snow

I followed Killswitch out into the snow in the parking lot in February. He wanted to get some air. I remembered when I was a kid, I used to wake up Sunday morning, eat cereal, and turn on the TV. After cartoons all that was left to watch were religious programs and wrestling. Sunday was still a day of rest. The stores were closed. It was probably raining outside. I didn't really care much for wrestling but it was often on TV in our house and I still recall some of the wrestlers' names like Gene Kiniski and Don Leo Jonathon, and a place called PNE Gardens where it happened. The shows blended into the wallpaper, behind plumes of cigarette smoke as our family sat around the dining room table.

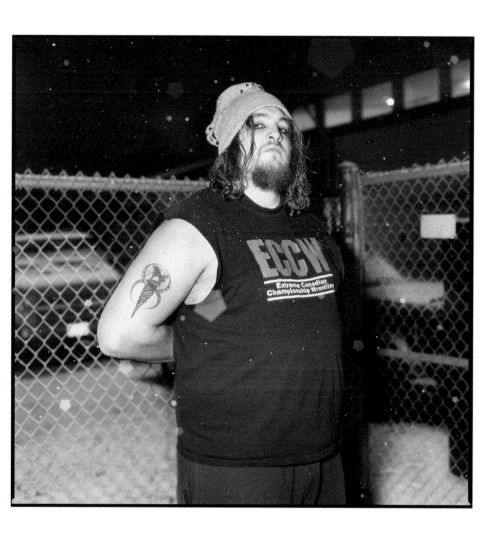

FAME

We were in a huge barn-like building on a Saturday in Nanaimo and a decent crowd filled the place. At intermission a man got into the ring to pose for a Polaroid with Madison and to get her autograph. He was very shy. I show Madison this picture months later and she remembers the guy, who she says is a big fan. Madison says she is flattered to be asked for her autograph, although she doesn't feel much different from anyone else. I ask her if she wants to be famous and she said that fame isn't as appealing as success. She had a taste of fame in Korea where she was mobbed wherever she went after one of her matches was shown on TV. At the moment she works a day job at a gas station. She's determined to move up in the wrestling world and figures she has a good chance. Her ultimate goal is to make it to the WWE.

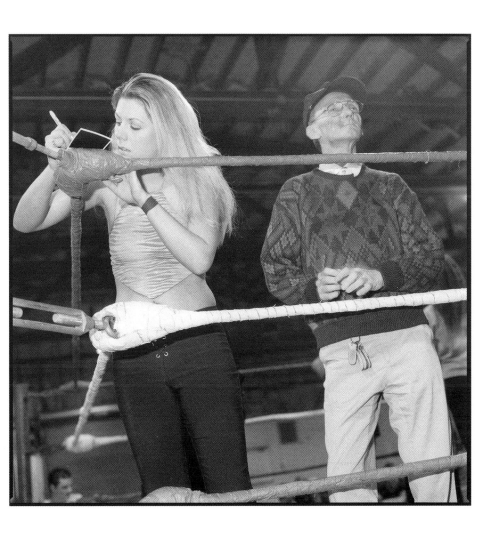

THE SHOW

It is not enough to simply set up a ring anymore. ECCW doesn't have the budget for big screens and the elaborate lighting that you see in WWE shows, but they do what they can, and they work with what they've got. Often the music is cued incorrectly, and the wrestlers have to turn on the flashing lights themselves before bursting through the curtain. The set decoration might be minimal but it's still effective in making the production seem more professional, and by putting the limelight on the wrestlers, helps to inspire them in their performances.

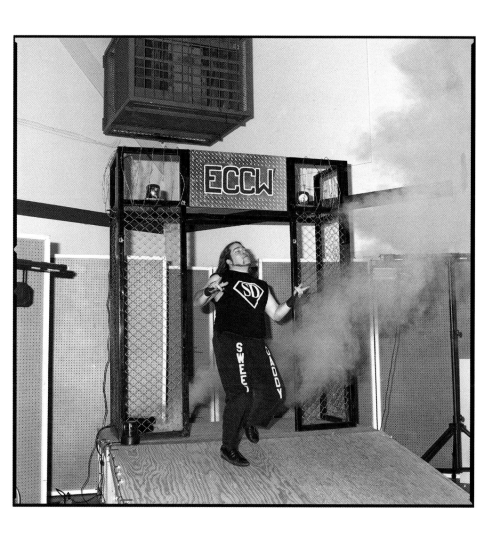

Kiss

Johnny Canuck and Gorgeous Michelle Starr are the tag team "The Glamour Order of Discipline." They enter the hall in a slow sexy dance, playing with their nipples and taunting the crowd. In most towns around the territory they would be heckled, but for some reason they are much loved in Surrey. The crowd roars as Starr pulls Canuck in close for a kiss, or when they dry hump the legs of their fallen and seemingly unconscious opponents.

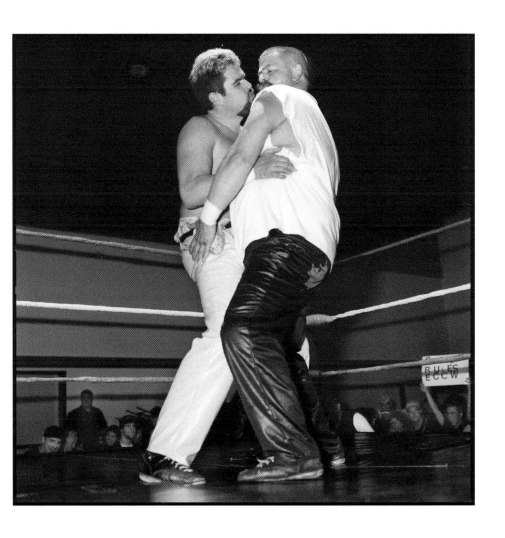

Nanaimo

The kid holding up the sign is the quiet one. He has a friend with him who is a real loud mouth and who managed to steal the early part of the show by his fierce heckling of Bulldog Bob Brown Jr who was battling The Cremator. The kids have traveled all the way down from Campbell River to see the show. I imagine them in the car on the highway, pulling out the felt pens and flattening out the cardboard.

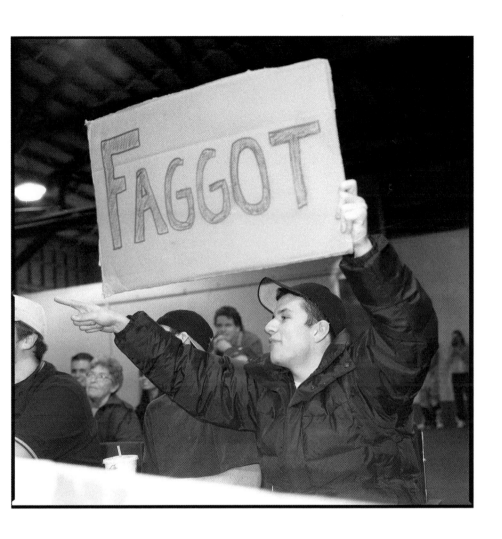

Finger

Ladies Choice struts into the hall and strides up to the front row. He circles the ring holding his nose to indicate his disdain for the audience. By the time he gets into the ring, people are shouting at him. The role of heel only succeeds when the fans get angry. Ladies Choice waves his arms and asks for silence so that he can remove his sunglasses and the shouting and heckling grows louder and meaner until he has the crowd where he wants them. Then his opponent, The Honky Tonk Man, enters the room and the crowd leaps to its feet, cheering wildly, prepared to receive him as they would a conquering hero.

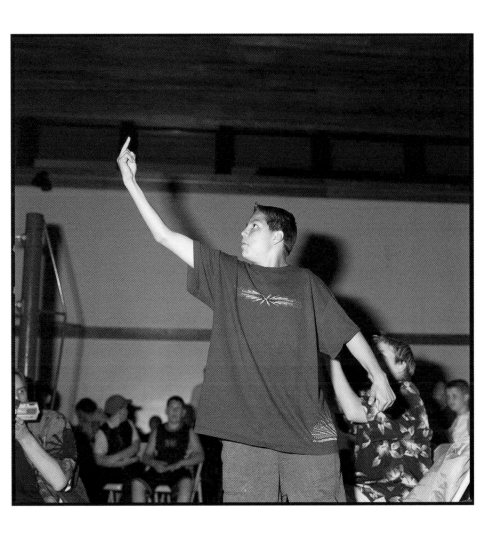

"It is not enough to defeat your opponents, you must also humiliate them," says Michelle Starr. Brian Summers lost the "loser gets a makeover" match to Starr, who as his reward got to perform the makeover. First he stuck Summers in a chair in the middle of the ring and headlocked him into a "trance." Then with the help of a few fans happy to assist, he covered Summers in makeup, stuck a wig on his head, and wrapped a feather boa around his shoulders. As a final touch they wrote on his forehead with lipstick.

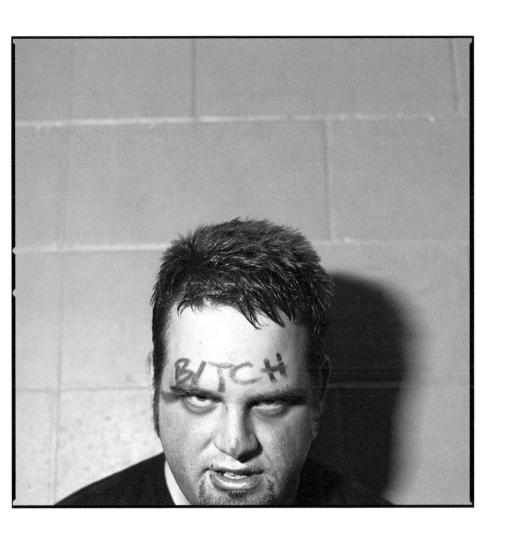

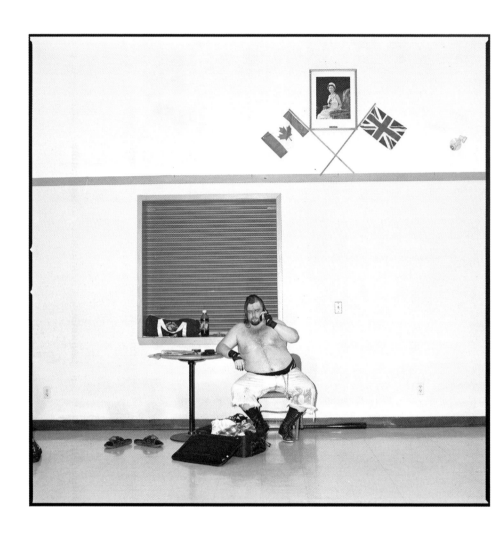

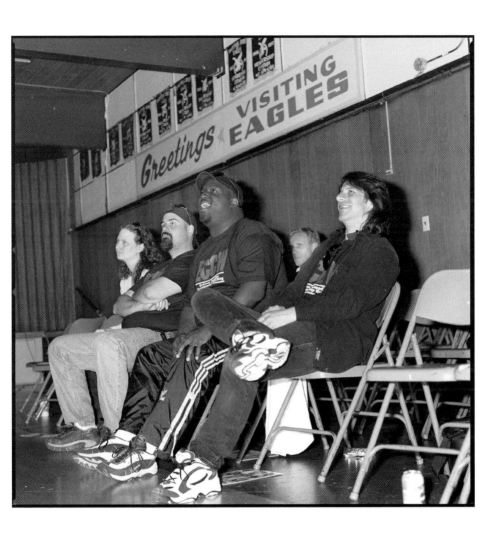

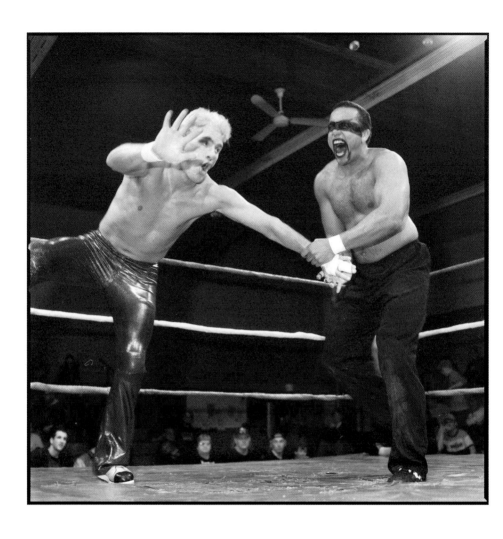

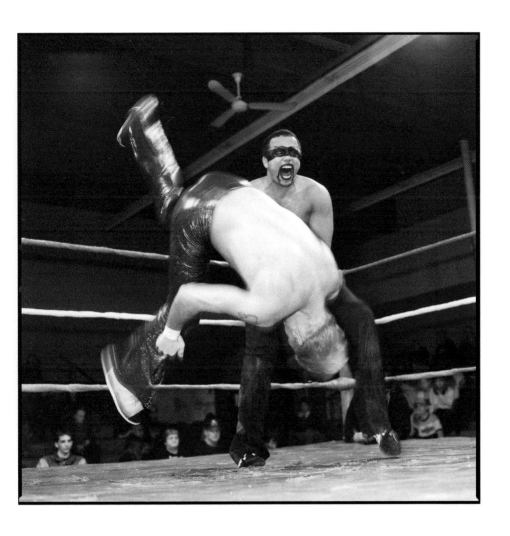

Wrestling is a finely choreographed dance in which the opposing wrestlers work as a team. They are responsible for each other's safety in the ring. When a wrestler comes off the top rope, his opponent has to know how to catch him. Beautiful Bruce took several stitches in the head when he was tossed from the ring and Michelle Starr accidentally dropped him. In another match Killswitch made a mistake that caused Cheechuk an injury. Backstage, Killswitch was sitting with Cheecuk's foot in his lap, unlacing his boot. "It could be me next time," Killswitch said. "We'll have to fight again and I need to show him respect for fucking up." The sequences are worked out backstage, but there is room for spontaneity and random change, and things can go wrong. Muscles are torn and injuries sustained. The show goes on.

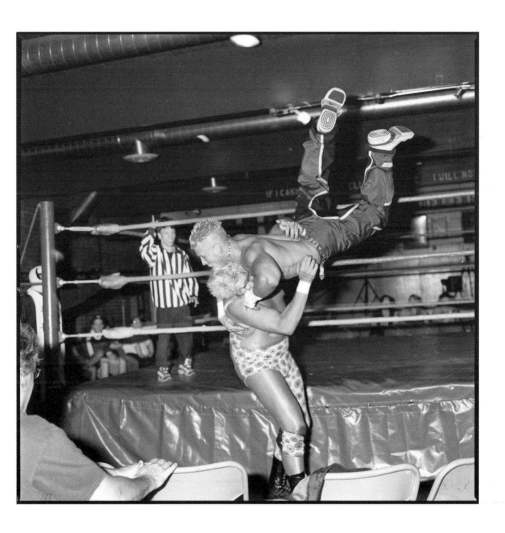

Timing

There were about forty fans in the building when Skag Rollins, who weighs three hundred pounds, dove off the top rope onto three wrestlers assembled on the floor outside the ring. Something went wrong and Skag hit the ground hard and got up slowly. Backstage, the others could tell that he had been hurt. His injury had come at the worst possible time, Skag said later. He had taken a few days off work and was counting on his wrestling pay to cover part of his rent.

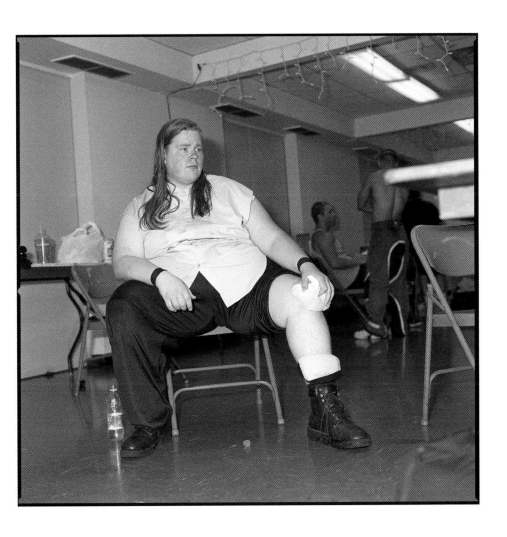

The Job

Bam Bam Bambi says: "The same fans who had been chanting: 'Slut! Slut! Slut!' at me, and 'Jenny Craig! Jenny Craig!' come up at intermission and offer compliments. 'You look nice,' they say to me. 'I enjoyed your match.' They apologize and say, 'I hope you didn't mind those earlier comments.' I smile and say we're both just doing our job."

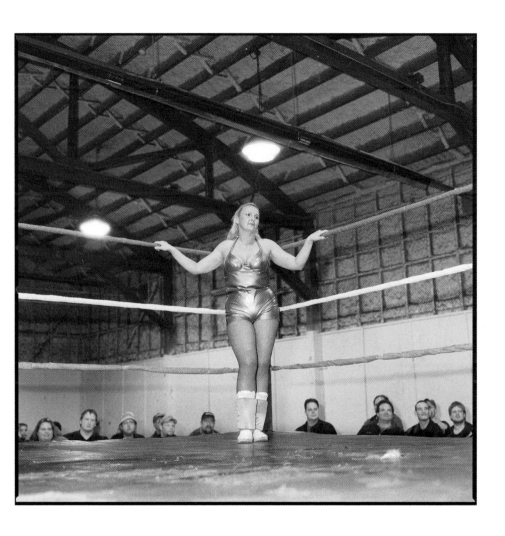

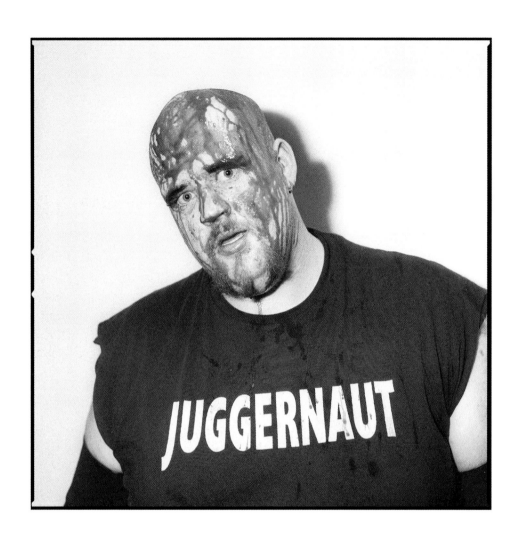

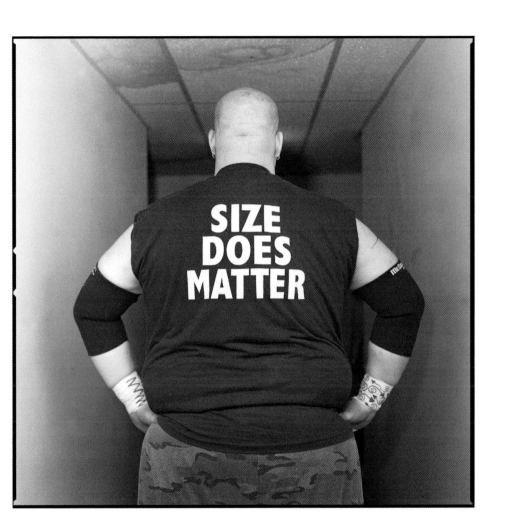

CHAIR

The folding metal chair, dented and blood-stained, is a common sight at the shows. This one had been placed in the entrance tunnel at the Port Alberni Athletic Hall. The dents are the result of contact with human heads and the blood is fresh from last night's show. The folding chair is a favored weapon. It has a certain amount of give to it, which tends to protect wrestlers from serious injury (it still hurts). Fans love to see the "chair shot" and sometimes one will even take a mangled chair home as a souvenir.

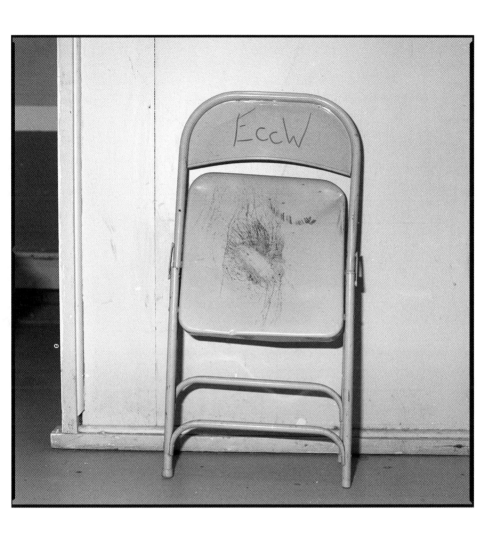

WEAPONS

Promoters encourage audience participation, going so far as to host "Fans bring their own weapon" nights. At the door, fans leave their weapon of choice, which will later be used by the wrestlers. Crowds get a particular thrill out of seeing Moondog Manson work Juggernaut with a skateboard, a cookie sheet, or any other item they contribute to the show.

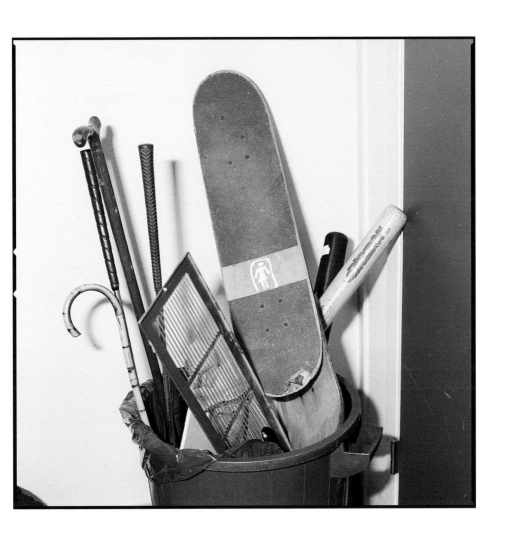

Pain

Pain is always overstated: in wrestling all pain is seen to be ex-
treme pain. The fallen wrestler is not only hurt, he is powerless.
He has lost all of his ability to function, he is finished. In a mo-
ment he will rise from near death and destroy his opponent. Pain
is also at the heart of a fan's attraction to wrestling: if a wrestler
does not visibly demonstrate agony, the crowd will not buy it,
even though they realize it's all an exaggeration anyway.

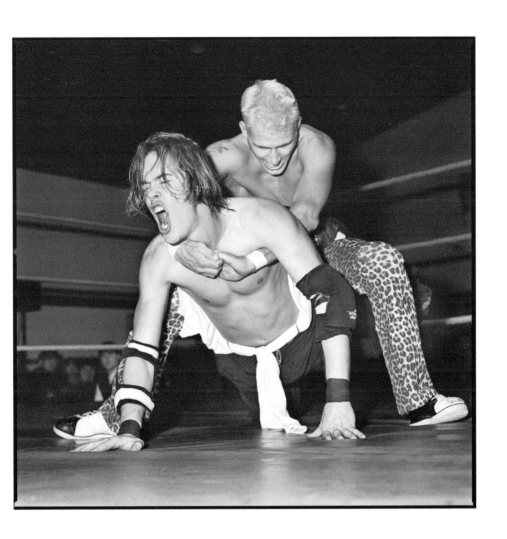

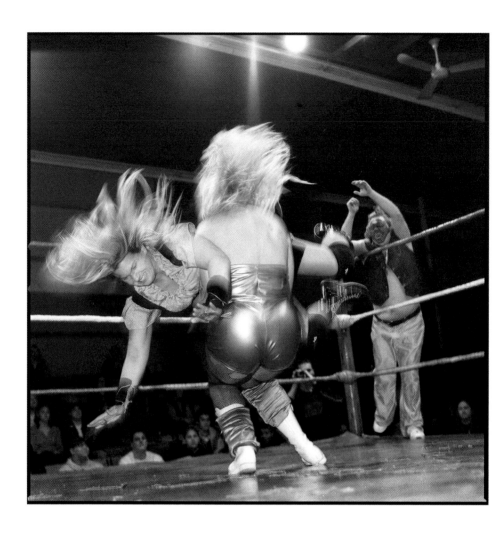

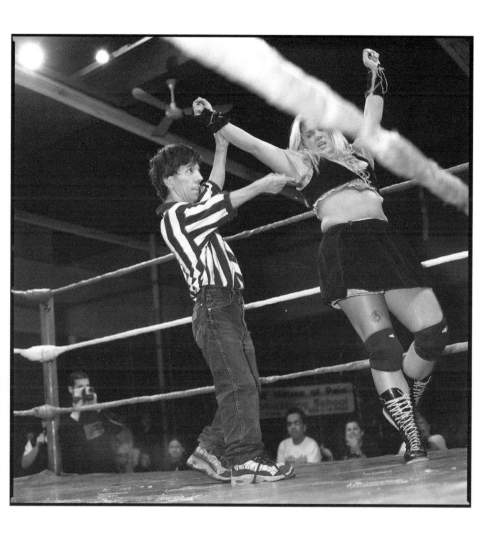

Backstage at the Bridgeview Hall in Surrey, Scott Schnurr waits behind the plastic curtain separating him from the crowd of two hundred. This is his night: he's to be crowned ECCW Heavyweight Champion. His opponent is Black Dragon, who is already in the auditorium, working the crowd from the Cage. Scott's faithful fans are shouting insults at Black Dragon and calling out for Scott. The voice of the announcer rings out over the cracked sound system: "And now, from Sun City, California, weighing in at two hundred and fifteen pounds – Scotty Maaac!"

Scotty Mac has never been to Sun City, California. He was born in Kelowna, BC and raised in Richmond. But once a week somewhere in a darkened auditorium, he becomes the superstar wrestler from California. U2's "Elevation" blasts from the speakers and Scotty Mac bursts through the plastic curtain. The fans are on their feet cheering and whistling, and the teenaged girls are screaming and wailing.

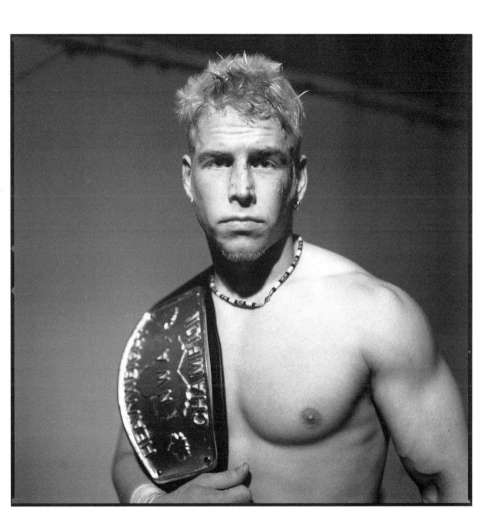

Cage

Scotty Mac battles hard with Black Dragon for a quarter of an hour, and then Black Dragon is down, laid out on the canvas, unable to move. Scotty starts his slow climb up the wall of the cage, his bleached blonde hair stained with blood from a cut on his forehead. The roar of the crowd gets louder as he climbs. They know a huge finish is coming. Scotty gets to the top of the cage and stands up and looks down at his opponent lying prone twelve feet beneath him. He leaps without hesitation and hits the mat in a perfect leg drop. Then, finally, triumphantly, he pins his opponent. The crowd is chanting, "Holy shit! Holy shit!" Some of the girls in the audience weep for joy. Scotty goes backstage where the other wrestlers congtratulate him. Wrestler Layne Fontaine peers out from the curtain and is visibly moved by the tears streaming down the faces of the teenaged girls.

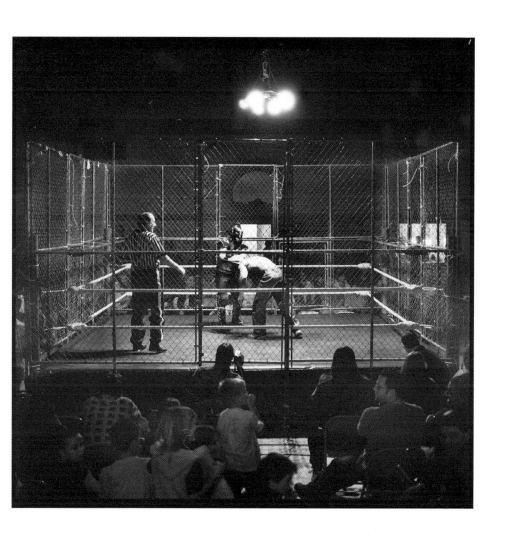

The Road

Part of the allure of being a wrestler is the road travel. ECCW often plays in a different town every week. It's an experience to be on the road but a struggle for some wrestlers to get away from their day jobs to work small towns for twenty to fifty dollars a show.

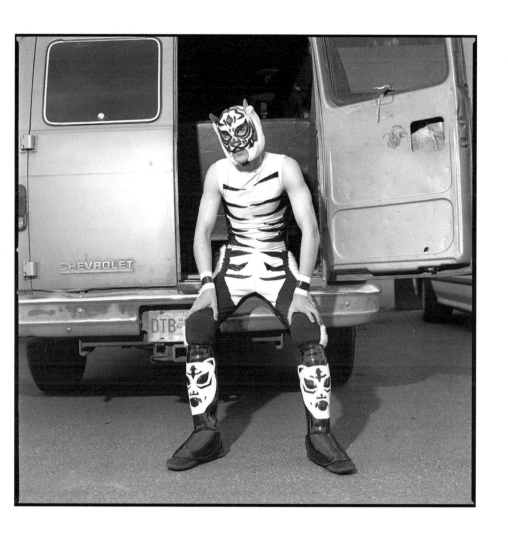

Laundry

We stayed in a hotel that would normally be closed for the winter season. Not too many tourists show up in Ucluelet in February. It was pouring rain outside and the warmth of the room was a pleasant surprise. After the show we hung out talking about the business – Moondog Manson, Wrathchild, Bambi, and her nephew Mikhail. It was getting late when Wrathchild headed toward the washroom. He had to stop and ask Bambi to remind him whether it was cold water or warm water you needed to get the blood stains out.

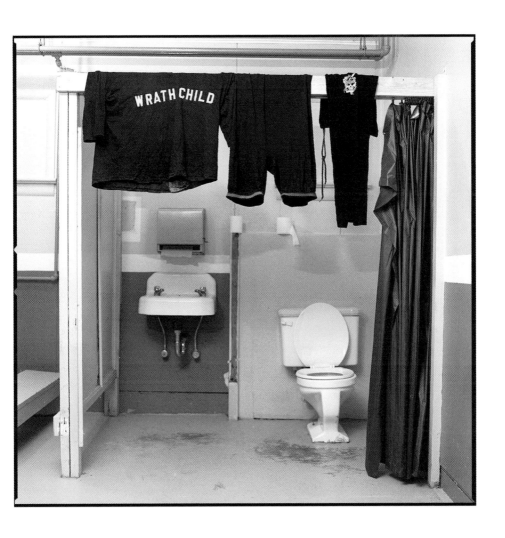

REALITY

Moondog Manson says: "Wrestling is an escape from reality. It's all about drinkin', shit kickin', and having a good time. It's like being paid to be white trash."

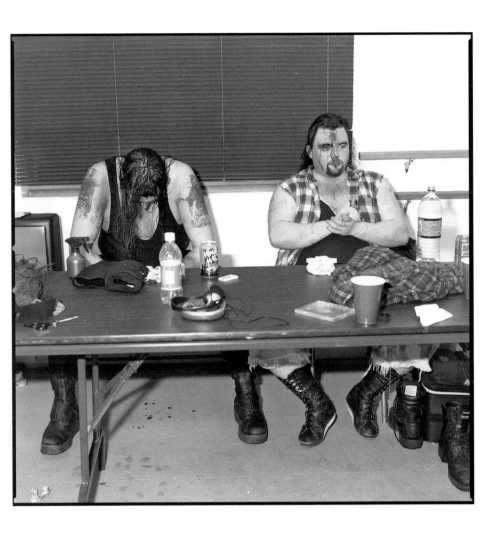

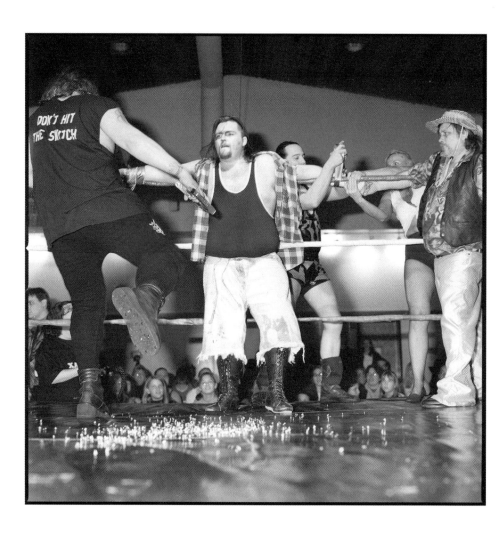

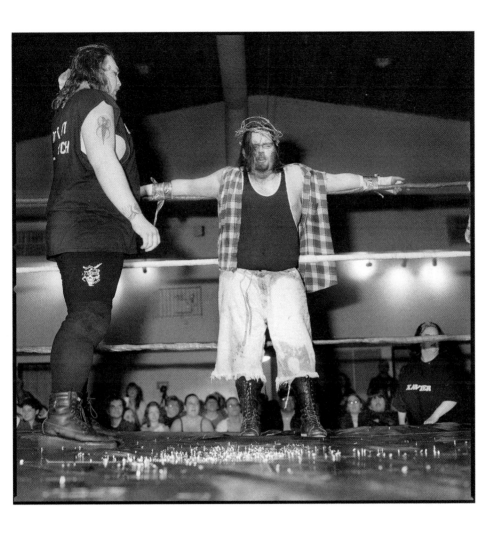

Good Friday

It's Easter weekend at the Bridgeview Hall in Surrey and backstage the air is buzzing with preparation. Wrists are being taped, boots tightened, matches planned. Amongst the chaos, Wrathchild wraps duct tape around a staple gun. Blood trickles down his left forearm where he has driven two staples into himself. A test to see how tonight's prop will work. Later in the evening he will drive staples into the arms of his opponent, Moondog Manson, in a mock crucifixion. The match begins in classical hardcore style. Very little of the action takes place in the ring. Chairs collide with heads, blood flows. Other wrestlers appear and join in against Manson: T.J. Sleaze, Bambi, Killswitch, and the Count. They overpower Manson and fasten his arms to the rope with duct tape. A barbed-wire crown appears on Manson's head. Wrathchild has the staple gun in his hand. He calls out to the crowd: "Two thousand years ago they crucified the King of the Jews. Tonight we're crucifying the King of Hardcore!" He drives a staple into each of Manson's arms. The crowd gasps, some people laugh. Is this fake or real? At this point Father Juan Valdez runs into the hall, screaming, "This is blasphemy!" Johnny Canuck appears out of nowhere, grabs the staple gun, and drives a staple through a sheet of paper into Wrathchild's forehead. Eventually the wrestlers are pulled out of the ring and escorted backstage. After the show, while the younger, newer wrestlers are tearing down the ring, Wrathchild poses for pictures with the staple still in his head. Later he says: "The fans keep pushing us to go further. I don't know what I'll do next time. Maybe I'll have to take a gun and blow my head off."

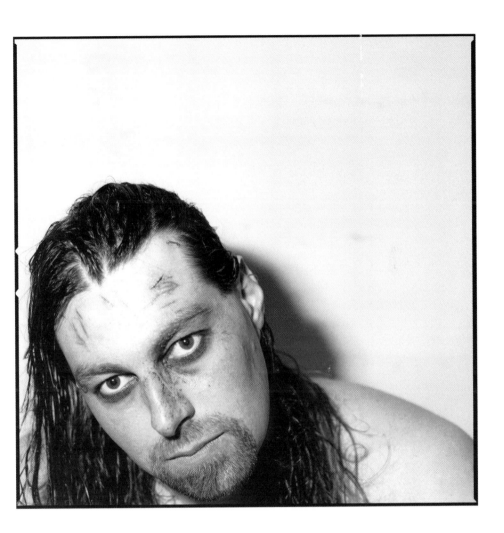

Some of the fans complained about the Good Friday Show, which had featured the crucifixion of Moondog Manson as well as the staple-gunning of Wrathchild. Father Juan Valdez, an ordained minister who used to be a referee named Mr Thug, was once a regular member of Backwoods Militia, said: "What were those good people doing at at wrestling show on Good Friday? What did they expect?"

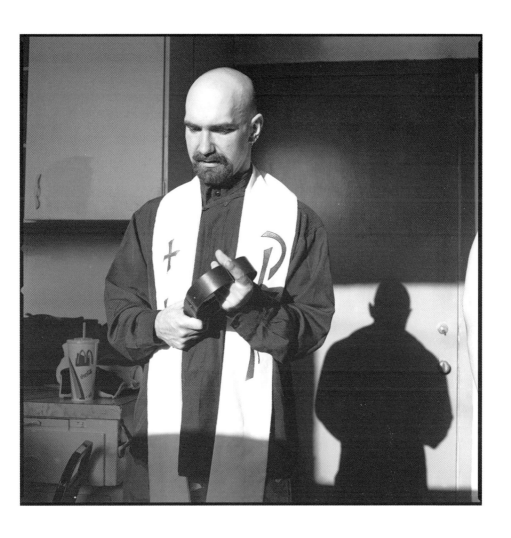

MOTEL

After the match Moondog Manson leaves the hall and walks to the local 7-Eleven for a pizza sub sandwich. He still has the baseball bat in his hand and there is blood on his face, but all he wants is a late-night snack. In the glare of the fluorescent light in a small town after midnight, I sense he feels himself becoming human again. At least until the next show.

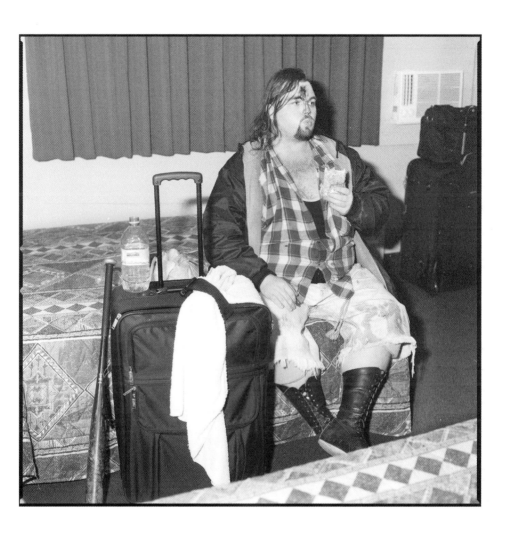

Veterans

Ladies Choice and The Honky Tonk Man discuss their match backstage before appearing in front of a packed house of 350 at the Bridgeview Hall in Surrey. The Honky Tonk Man performed in front of thousands when he was with the WWF. Those days are behind him now as he continues to wrestle at indie shows in small halls.

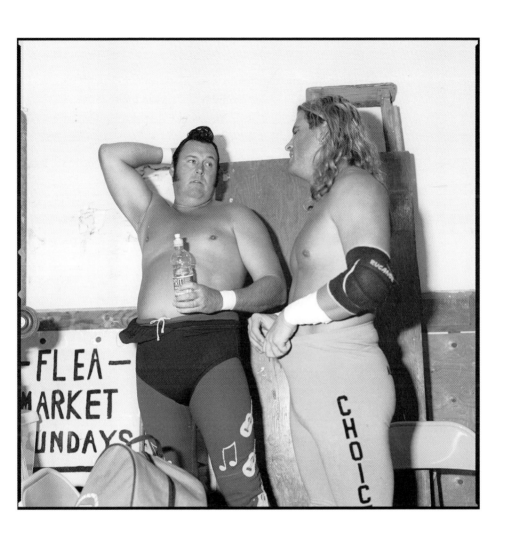

The Toll

Wrestling is a performance art that extorts a toll. Concussions from taking a chair to the head, heavily scarred foreheads from self-inflicted cuts, dislocations, joint pain, and broken limbs are all accepted risks of the profession.

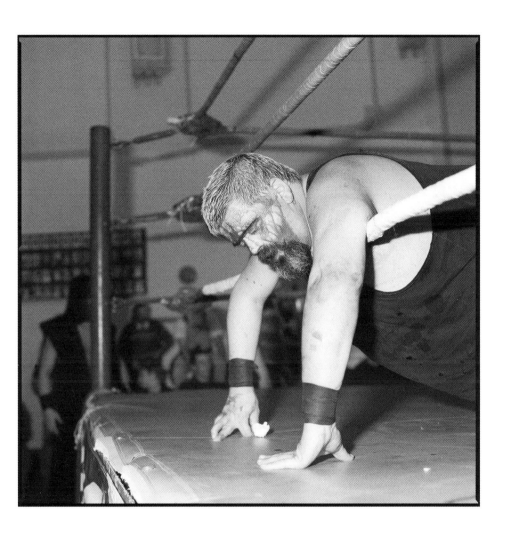

Linda

Linda is usually seen in her front row seat, calling out, "Ass-hole!" in her distinct, high-pitched voice. Tonight she waits at the back of the Eagles Hall in New Westminster with a bundle of carnations individually wrapped to hand out to her favorite wrestlers, as well as some whom she hates.

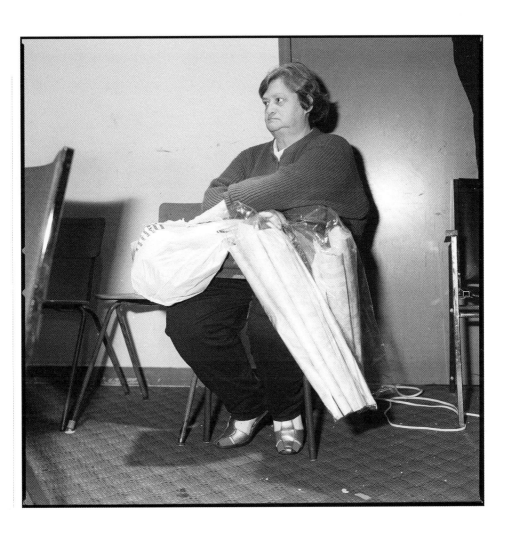

Acknowledgments

This publication would not have been possible without: the co-operation and support of Mark Vellios (Gorgeous Michelle Starr), all of the ECCW wrestlers, and their fans; the input and assistance of indie wrestling afficionado Marty Goldstein, who is recognized across North America as an expert on the business and is the associate producer of *BC Bodyslams*, a documentary film about ECCW ; the support, patience, and love from my wife Kate and her family, all of whom became wrestling fans; Annastacia McDonald, who encouraged me to attend my first wrestling show and has always been supportive of my work; my brother Mike, who accompanied me to the early shows in New Westminster and subsequently wrote a number of stories about ECCW; John Solowski whose precious words and passion for seeing will forever be influential; my friends and colleagues Brad Cran, Stephen Osborne, David Campion, Christopher Morris, Chuck Russell, Paul Wong, Chris Campbell, Charles Haynes, Dennis McDonald, and Joe Sarahan who repeatedly offer their support and insight; and the support of *Geist Magazine, Saturday Night Magazine, The Royal City Record, Surrey Now*, and *The Globe and Mail*.

In memory of my father, George Howell, who passed away during the making of this book.

TEXT + PHOTOGRAPHY =

PARALLAX

A NEW SERIES OF BOOKS FROM
ARSENAL PULP PRESS

Parallax, a new series from Arsenal Pulp Press,
publishes books that explore the far reaches of
the modern world, proposing new perspectives
on how we see ourselves through the eyes
and the words of our most intriguing
photographers and writers.

Also available:

WHERE FIRE SPEAKS
PHOTOGRAPHS BY DAVID CAMPION
TEXT BY SANDRA SHIELDS
INTRODUCTION BY HUGH BRODY
ISBN 1-55152-131-8

Available at better bookstores,
or from *arsenalpulp.com*